SCRATCHING THE SURFACE

ART AND CONTENT IN CONTEMPORARY WOOD

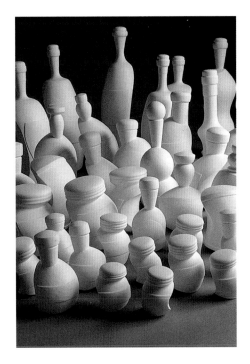

SCRATCHING

GUILD Publishing

Madison, Wisconsin

•

Distributed by North Light Books

Cincinnati, Ohio

THE SURFACE

ART AND CONTENT IN CONTEMPORARY WOOD

MICHAEL HOSALUK

SCRATCHING THE SURFACE

Art and Content in Contemporary Wood

Michael Hosaluk

Published by GUILD Publishing

An imprint of GUILD, LLC

931 East Main Street

Madison, Wisconsin 53703

TEL 608-257-2590

FAX 608-257-2690

Design: Jane Tenenbaum

Chief Editorial Officer: Katie Kazan

Project Editor: Jill Schaefer

Distributed by North Light Books

An imprint of F&W Publications, Inc.

4700 East Galbraith Road

Cincinnati, Ohio 45236

TEL 800-289-0963

ISBN: 1-893164-15-2

Printed in China

Copyright © 2002 GUILD, LLC

08 07 06 05 04 03 02 7 6 5 4 3 2 1

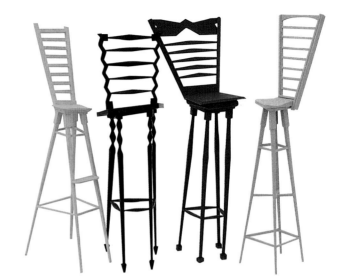

Front cover artwork: John Cederquist, *Folded Fish Bench,* 1999, birch plywood, Sitka spruce, poplar, maple, epoxy resin, aniline dye and lithography ink, 40" x 62" x 30". Photo by Mike Sasso. A detail of this piece appears on pages 2 and 3.

Page 1: Mark Sfirri, *Blank Canvas,* 2000, poplar and paint, 2" to 13"H.

Above: Robert Dodge, *Bridge Foursome,* 2001, wood and paint, each 24" x 6" x 6". Photo by Robert Dodge.

Page 31: This image courtesy of the Mint Museum of Craft + Design, Charlotte, North Carolina. Promised gift of Jane and Arthur Mason.

Visit GUILD.com, the Internet's leading retailer of original art and fine craft.
www.guild.com

CONTENTS

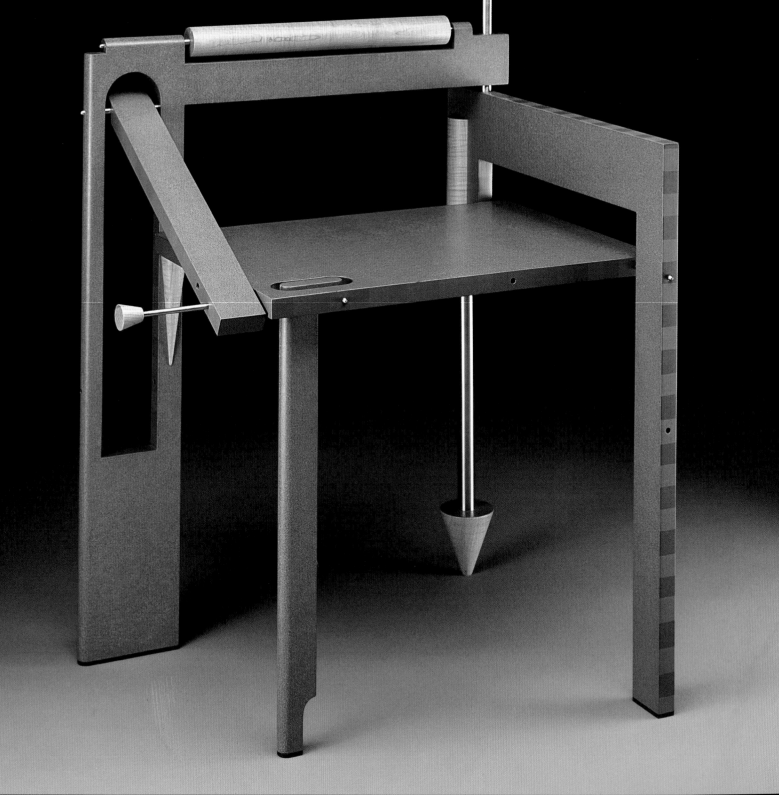

AGAINST THE GRAIN

Judy Coady

A quick survey of historical wooden works shows that the application of color to wood is an old-fashioned habit. Ancient Egyptians painted their ridiculous wooden pillows. Frenchmen gilded chairs for the Louis kings. Dutchmen in Pennsylvania stenciled every plank in sight, and in the 1970s, the Rochester Folk Art Guild colored toy tops and reversible puzzles. Today, Smithsonian staff artisans cyclically faux-paint the "mahogany" entrance doors and millwork of the Renwick Gallery, which houses "The Nation's American Craft Collection." Decorating and disguising wood has plenty of precedent.

Contemporary American studio artists who paint, stain and flame wooden objects come from a university — rather than an apprenticeship — tradition. They have the technical skills to cut tight dovetails, and can sand and oil veneers until the wood shouts its glory. Steeped in the history of furniture design, they can also reproduce a seductive Queen Anne leg or Chippendale foot. Yet they choose not to.

Such studio wood artists want their aesthetic voices to be heard over, or at least in harmony with, the seductive call of polished wood grains. They have aesthetic statements to make: intellectual, political, social, humorous and sexy three-dimensional artistic statements. They opt for wood to express their creative visions, and most choose wood as their preferred medium because its fiber accepts color with great empathy. Painted, stained, bleached or burned, wood grain has a sensuous patina. By contrast, steel, glass and marble are far less sympathetic to surface color. Then, too, wood is more versatile to manipulate and transport than its sister sculptural materials — and it smells better.

The tools used to fashion wood still include the historic woodworker's repertoire of planes, chisels, adzes, hammers and saws. Electricity has provided contemporary artists with the additional power and precision of motorized equipment such as band saws,

OPPOSITE: Tom Loeser, *Folding Chair*, 1988, Baltic birch plywood, maple, stainless steel and paint, 34" x 25" x 22".

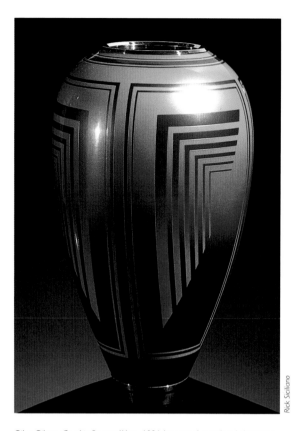

Rick Siciliano

Giles Gilson, *Graphic Reversal Vase,* 1986, lacquered wood and aluminum, 13" x 7". "These colored surfaces require a lot more work, knowledge and preparation than traditional finishes. Most cultures in history painted their woodwork and honored painted wood."

moves. It shrinks and swells with seasonal vagaries, remaining vital until it is either petrified or turned to ash. Throughout history, successful woodworkers have respected wood's liveliness by employing appropriate building techniques. Careful compensation for wood movement is where all issues of master craftsmanship begin and end.

That said, I reject the notion that contemporary woodworkers are basically following their antecedents along the trail of hand-crafting useful and well-made objects. In Western society, commercial manufacturers now provide nearly all of the wooden products that earlier societies sought from the artisans' hands. This industrial revolution has broken the natural evolution of fine woodworking. University instruction has replaced most of the traditional apprenticeship training in woodworking skills.

The component of intellectualization has been plunked on the workbench largely as a result of the academic training of wood-workers. When broadly, liberally educated men and women lay hands on wood, the resulting objects inevitably express aesthetic concepts in addition to, or in place of, function. Turned wood bowls may or may not be useful salad servers. Chairs just might work as seating, but not necessarily so. University-trained woodworkers are not just trying to build a better mousetrap, or a more comfortable chair. They are engaged in artistic self-expression and use wood, paint, stain, bleach and blowtorch to create art.

Woodshop terminology has changed to describe this contemporary aesthetic focus. With this new vocabulary, the makers are now celebrated, or at least described, as "studio artists." In the parlance of museum curators and collectors alike, the products from their woodpiles are "studio arts" rather than "decorative arts." In the 1980s, Art Espenet Carpenter, a foxy traditional furniture maker of great international repute, referred to the newfangled work as "artiture." Compliment or not, no con-

chain saws, slot mortisers, planners and high-speed lathes. While much parlor furniture of the nineteenth century suffers from peeling horse-glue veneers, modern synthetic glues and finishes now give works a hitherto unknown durability. Scientific innovations and inventions provide woodworkers with an unprecedented vocabulary of techniques, as well as increased longevity for their works.

The only remaining historical tenant of fine woodworking that contemporary practitioners must respect is the basic rule: Wood

temporary woodworker disputes this now-coined nomenclature. The nonfunctional works featured in this book are properly referred to as either "furniture oriented" or "vessel oriented," as the case may be.

Contemporary wood artists who pay mere lip service to function and subjugate the beauty of natural wood to overall sculptural statement are vitally concerned with aesthetic expression. Many are articulate teachers, writers and speakers on their own work and on the field in general. These artists are alive and available for comment; writing in this book, Michael Hosaluk and Paul Sasso are cases in point. They both provide a refreshing respite from the haughty game of fine art.

Exposure to such contemporary artists and their creations has enriched my life, maybe even saved me from the mainstream. I have learned that Ed Zucca makes art furniture "because buildings are too big and jewelry is too ditzy," and that Judy Kensley McKie struggles to make her carved animal-like forms ride the razor's edge between fantasy and cartoon. I now know that Garry Knox Bennett works toward a visual impact like the perfectly timed punch line of a well-told joke, and that Rosanne Somerson strives for subtle yet innovative residential furniture that "entices with a whisper."

I have no wish to distill the aesthetic pursuits of these artists into one-liners; instead, I hope to provide a glimpse into the creative intellect that contemporary wood artists bring to their work. Their objects are not the result of a moment's creative genius but rather weeks of dedicated workmanship. Ed Zucca once told me that the greatest creative challenge in working with wood is in keeping the aesthetic concept fresh during the labor-intensive building process.

Historical wooden objects — often painted — were made to have distinct functions, whether to hold blankets for the coming winter or to amuse, like a spinning top. In every case, decora-

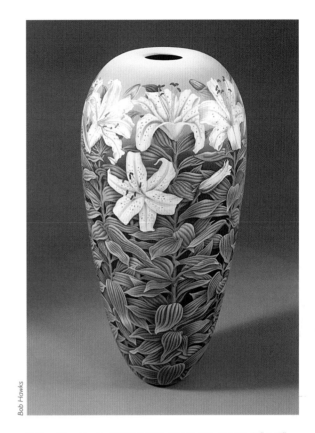

Patti and Ron Fleming, *Yami Yuri*, 2001, basswood and acrylic, 36" x 17".
"The design is from the mountain lilies of China. They are life-size."

tion was added as an embellishment. Unlike these cherished antiques, the items in this book have colored surfaces that are part and parcel of the works themselves, critical to the original aesthetic concept. The contemporary wooden works in this survey, whether functional or not, are all nonessential items. Such is the luxury of art.

Judy Coady is a curator, lecturer and ongoing student of the contemporary American craft movement.

BOARD WITH BROWN

Paul Sasso

In postwar Canada, circa 1945, a man driving a truck made a wrong turn. His mistake took him on a 33-mile dead-end trek through the northern Ontario bush. The area he traveled was the benchmark for the term "backwater." This region, on the edge of the Canadian Shield, sported enough topsoil to be an ideal habitat for white pine, birch and sugar maple. Logging and fur trapping were the economic choices for the few inhabitants of Scots-Irish descent. Where the clear-cuts left scars, brave souls cleared the stumps, and the land was able to support a single crop of potatoes or hay, and enough forage to raise cattle. Given the severity of the winters, existence was hard. The local joke was that supper was always potatoes and rabbits. Nonetheless, the more industrious settlers built some very fine farmhouses. The resource available to them was wood, and the interiors were sheathed entirely in tongue-and-groove white pine (often with beaded detailing) that was expertly installed. It was obvious that skilled craftsmen executed this work.

The truck was filled with cases of paint in two colors: turquoise green and salmon pink.

I came to this region as a totally naive city kid, caught up in the back-to-the-land movement of the early 1970s. I built a small house on an isolated former potato farm owned by my uncle. We had no electricity or running water, and romanticism became an ephemeral notion when faced with the sheer weight of survival. During the short summers, I worked as a carpenter to make enough money to subsist through the winter, when employment more or less came to a standstill. Because I worked for relatively little pay, my clientele consisted almost entirely of elderly women who lived in the wonderful old farmhouses where they had been born and raised.

The white pine interiors of these houses were painted either turquoise green or salmon pink or, more often than not, both.

This is how I learned the saga of the truck driver's mistake. I was working on a rather large old farmhouse owned by two old-maid sisters. They were in their eighties, and

their father had built the structure. The interior was painted in the aforementioned colors. As a confirmed "woody," I asked one of the sisters why in the world anyone would paint such beautiful woodwork, to which she replied, "Well, son, after living for so many years with 'brown,' you tend to desire something a little bit different."

She told me the story of how the truck driver who ended up in this backcountry had taken advantage of the situation by setting up shop on the side of the road, selling his load to the locals. They bought freely with the expectation of "something a little bit different." Gloomy interiors were transformed into ice-cream parlors. Little did I know at the time how the truck driver's mistake would not only change my fundamental thinking about wood, but also teach me an important lesson pertaining to human nature.

There are essentially two ways to approach the painting of wood. The first is one of pure decoration, where the surface is coated for the purpose of pleasing the eye. The sisters' farmhouse is a good example of this treatment. The other approach is more complex, and delves into the sublime. When paint on wood expresses an intended idea, the results become the path and purpose of Art. When we travel down this noble path, we not only discover our place in the world but also become chroniclers of the times we live in.

Paul Sasso is a studio artist and professor of functional design and woodworking at Murray State University in Kentucky.

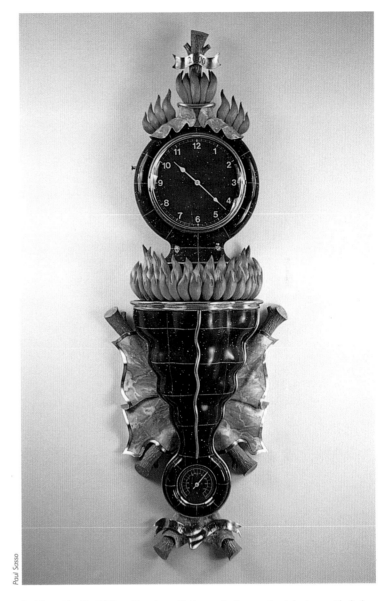

Paul Sasso, *New Era,* 2000, acrylic and metal leaf on poplar, basswood and aluminum, with clock movement, thermometer, glass and brass, 57" x 20.25" x 8".

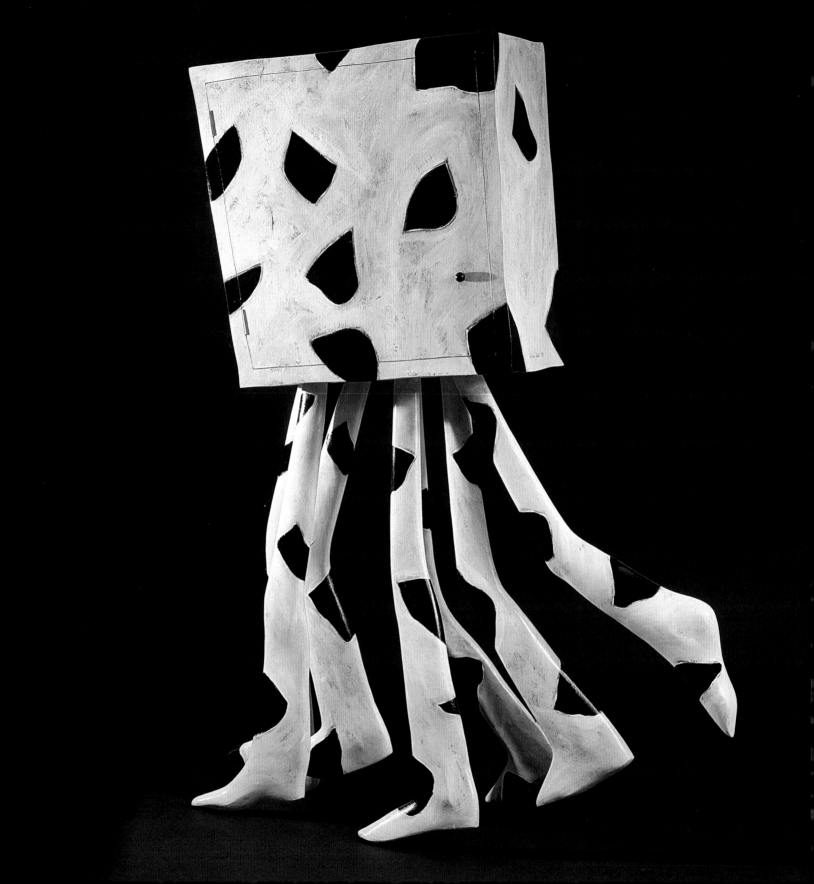

SURFACE EFFECTS

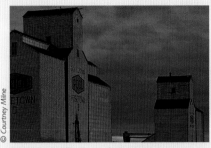

© Courtney Milne

Grain elevator, Rosetown, Saskatchewan.

W hen I was four years old, we would use materials we found around the farm to make crossbows. On a good day, we could shoot the top windows out of a grain elevator. I have always loved making things. I grew up in an environment where handwork was a way of life, in a culture that was vibrant and colorful, where my imagination could run rampant.

As makers of art, we celebrate life. Our lives become our work, and in our lives we find defining moments where change for the better occurs. We find ourselves becoming more intimate with our work, and our richer lives send us reeling in exciting new directions. We don't always have a plan; we do things just because we want to. When we truly let go, when we remain open to new and unusual subject matter and simply create, it is a very liberating experience.

So what of our colorful past? Tommy Simpson was painting wood before I reached puberty. He first exhibited painted wood furniture in 1966. While a handful of maverick artists exhibited painted wood at this time, it wasn't until the early 1980s that a group of makers using surface design truly emerged. Although they were considered rebels, the traditional channels through which they displayed their work garnered attention, and the public was unable to deny them their place in the current wood movement.

OPPOSITE: Wendell Castle, *Walking Cabinet,* 1987, mappa burl interior with painted exterior; legs: painted cast aluminum; 63" x 50" x 18".

David Margolis

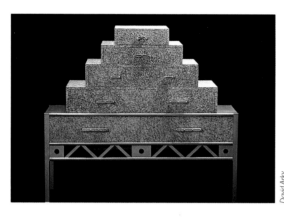

David Arky

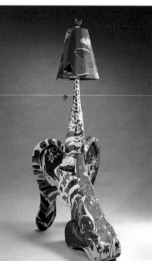

William Seitz

ABOVE: Ed Zucca, *Middleboy*, 1981, basswood, poplar, paint and Erector-set parts, 52" x 60" x 19". "Shorter than a highboy, taller than a lowboy."

RIGHT: Tommy Simpson, *LBJ*, 1966, painted wooden floor lamp, 70" x 40" x 28". "This piece was made for a show in Chicago about President Johnson. The lamp illuminated the stars-and-stripes landscape as well as the presidential ears and nose of LBJ."

BELOW: Wendy Maruyama, *Blanket Chest*, 1990, poplar and paint, 46" x 22" x 18".

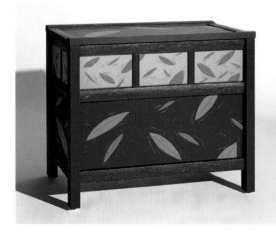

Cary Okazaki

In its first show, in 1980, The Gallery at Workbench, in New York City, showed painted and dyed furniture by Garry Knox Bennett. Throughout the 1980s, the gallery's directors, Bernice Wollman and Judy Coady, initiated many exciting projects and provided furniture artists with an avenue for experimentation. Coady recalls, "No one would buy the work at first. It was shocking! People were not only asked to buy furniture, they were also asked to buy into the aesthetic and freedom of the artist."

Snyderman Gallery, in Philadelphia, also began showing avant-garde work in the early 1980s and continues to do so to this day. Across the street from Snyderman, the Kagan Gallery epitomized conventional wood furniture. When Richard Kagan saw Garry Bennett's work, with its metal and paint, he was appalled. Garry savored the reaction.

Fine Woodworking magazine also played a key role in the evolution of contemporary woodworking in the 1970s and 1980s. It illustrated new designs and techniques and provided a forum for artists who found themselves isolated from the mainstream. Wood artists of all stripes shared a respect for the art of woodworking, and yet there was such division in practice. Angry letters were sent to the magazine's editor reacting to the crayon-scribbled desk of Wendy Maruyama and to Garry Bennett's nail in the cabinet: "the Philistine who did that horrible thing to that cabinet." The reaction to Paul Sasso's early painted pieces was similar: "How dare you desecrate wood!"

"When we examine the whole idea of painted wood and the taboos of the 1970s," Sasso reflects, "it's kind of hilarious, considering how the rest of the culture was disco and polyester mad, with really bad shoes and bad haircuts." The 1960s and 1970s were times of change. Artists looked for new directions to satisfy their own needs and desires. Our addiction to making objects demanded that we be able to tell our stories and share the events

of our lives. We were creating art for ourselves first and fore-most, hoping others would buy into it.

Eventually, academic programs emerged in response to the demand of people interested in pursuing woodworking as a career. Under the leadership of Alphonse Mattia, the Program in Artisanry at Boston University was the first course at a major university to say it was acceptable to paint wood. "When I first started using paints and dyes in my work, in the 1980s, it was a mild sort of rebellion from what I saw as the tyranny of the woodiness of wood," says Mattia. There are now many programs in wood that stress surface design, including those offered at San Diego State University and the Rochester Institute of Technology.

Many independent wood artists were also introducing new ideas of surface design in the 1980s. Ed Zucca used paint to play with ideas of wood masquerading as other materials. His *Middleboy* chest had a faux-granite finish with Erector-set pulls and base. Michael Hurwitz's use of milk paint and texture renewed an old tradition that continues to be popular with woodworkers today. His work possessed honesty and intelligence. Tom Loeser's use of line and color reached beyond the realm of the studio furniture movement, capturing the viewer's imagination. Mitch Ryerson's work conveyed fun and humor, with a poke at culture for our enjoyment. As Bernice Wollman says, "These artists had the ability to make surface as potent as shape."

Having bridged the gap in the history of furniture-making, women have made a significant contribution to the current wood movement. Kim Kelzer recalls, "I remember Judy McKie doing all this different stuff to make marks on wood, and then she ended up burning spots on a bleached bench — it looked like leopard skin. It changed my life when I saw her doing this and making the cover of *Fine Woodworking*" (January-February 1984). Judy McKie's stylized furniture was fun and loose, a

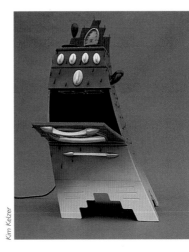

Kim Kelzer, *Home on the Range*, 1991, painted wood, Plexiglas, neon and aluminum, 36" x 22" x 20".

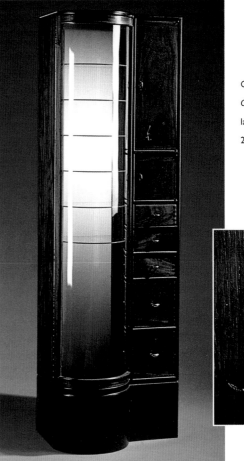

Garry Knox Bennett, *Nail Cabinet*, 1979, padauk, glass, lamp parts and copper, 74" x 24" x 17".

15

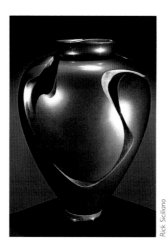

Rick Siciliano

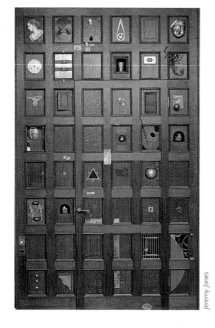

Jeremy Jones

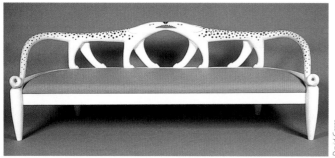

David Caras

breath of fresh air. Her move to paint represented a need to isolate the work for the sake of form and design; bare wood didn't complement the design of the object. Wendy Maruyama's furniture and sculptures explored color, texture and content. She continues to influence the work of present and future generations through her work and teaching. Today, women direct some of the top schools teaching creative woodworking, and surface design is a key element of their work.

Merryll Saylan's first color piece, *Jelly Doughnut,* was displayed alongside beautiful burl and exotic woods in the first North American Turned Object Show, in 1981. This opened the door to new exploration with color in wood turning. Kim Kelzer remembers, "More women were coming into furniture-making with a background in fine arts, decorative arts, fashion or craft. They didn't follow tradition or revere wood 'for wood's sake.'" Kelzer started painting furniture because:

> painting was the one thing I knew about, and I realized that even when I used different-colored woods, they eventually all oxidized to another shade of brown. Ugh! All the funk-ceramic art happening in the Bay area from the early 1960s to the 1980s was also a big influence. It made it acceptable to break tradition — to elevate craft to art.

Surface design continues to thrive thanks to an entire generation of men and women whose work influenced and contributed to the growth of design in contemporary wood. While the current movement has many influences, the emergence of Ettore Sottsass's "Memphis" group, in Milan in the early 1980s, had a tremendous effect on American studio furniture makers. The group's approach to furniture and objects offered an intellectual and theoretical rationale for exuberant, colorful figurative design. As Wollman recalls, "It also bore the imprimatur of fashion that interested the press."

This new aesthetic in painted furniture paralleled what was hap-

pening in the wood-turning movement in the early 1980s. Giles Gilson's background in automotive lacquers contributed to his interest in painting wooden vessels. Across the pond in Scotland, Liz O'Donnell reacted to the plainness of sycamore by adding color to her husband Michael's turnings. Stephen Hogbin and Hap Sakwa began adding color and meaning to objects. As Hogbin notes, "After working with wood for many years, I felt the rich surfaces begin to get in the way of the form. In contrast, color accentuated the form."

A number of exhibitions showed painted turned-wood objects in the early 1980s, but it wasn't until 1988, at the International Turned Object Show in Philadelphia, that it became evident that painted turned wood was here to stay. The critic reviewing the show for *American Craft* described one of the works as "painted beyond redemption." Artists were bleaching, dyeing, painting and lacquering wood, and the resulting criticism only spurred them to pursue this direction more vehemently. The wide repertoire of non-wood materials combined with wood offers the artist more latitude in his expression of ideas, but the content is similar. Gordon Peteran's work transcends function and takes us into a new consciousness of making. He, along with Bennett and others, immerses us deep in tradition, but with an aesthetic that has a voice full of contemporary meaning.

We have no formal degree programs in wood turning, and yet it is one of the most popular hobbies in the world. The Wood Turning Center in Philadelphia, under the leadership of Albert LeCoff, has been instrumental in uniting the international wood-turning community and in generating thought-provoking interaction with other media. There is a worldwide exchange of knowledge via workshops, conferences and exhibitions through the WTC and organizations like the American Association of Woodturners.

The Peter Joseph Gallery emerged on the New York scene after Workbench closed. The gallery represented the most innovative

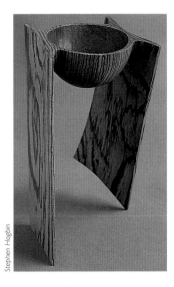

Stephen Hogbin

Ed Saylan

ABOVE: Merryll Saylan, *Jelly Doughnut*, 1980, poplar and acrylic plastic, 16"Dia.

LEFT: Stephen Hogbin, *Walking Bowl*, 1985, zebrawood and acrylic paint, 5.9"H

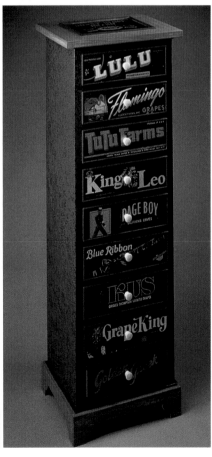

Dean Powell

LEFT: Mitch Ryerson, *Farmboy*, 1984, cherry, plywood, grape boxes, glass, labels and paint, 53" x 17" x 13".

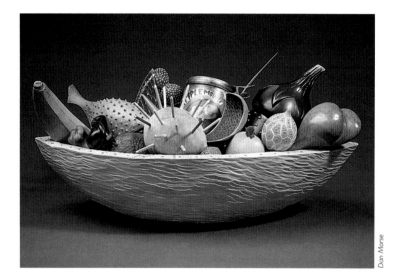

Emma Lake group, *Bowl of Unusual Fruit*, 2000, various painted woods, 25" x 12" x 12".

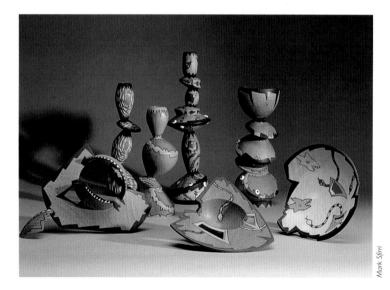

Mark Sfirri and Michael Hosaluk, *The Mark and Mikey Show*, 1993, curly maple, ash and mahogany, turned, painted and carved, bowls: 6"Dia.; candlesticks: 11".

talent and made it fashionable to own "art furniture." Its bold marketing strategies elevated wood art objects to a new level. In the 1990s, museums and collectors gave this work the respect it deserved, placing it shoulder to shoulder with other great collections. The Collectors of Wood Art had the vision to provide a forum, through annual conferences, to bring artists and collectors together; getting to know the artist is getting to know his or her work. Today, many galleries share this progressive vision of the future of art in wood.

Since 1996, the Furniture Society has united furniture artists, providing a platform for the exchange of knowledge and friendship. The exhibition *A Survey of Furniture in North America*, curated for this organization by Paul Sasso in 1997, indicated a strong direction toward artistic expression in furniture with surface design as a key element.

I am a student of this first wave of furniture makers and turners. Not having had the opportunity to attend a college or school, I benefited from local programs. The Saskatchewan Craft Council, along with the Saskatchewan Woodworkers Guild, created workshops and conferences that strongly influenced the current surface design movement. During the semiannual Emma Lake Experience, in Saskatoon, a group of artists gather from around the world to have fun making art collaboratively, with a strong focus on furniture, turning and metal. Gordon Peteran reports that "Emma sends a ripple that is felt globally." Our collaboration recalls the excitement of the field's origins, and an invigorated group of makers emerges from these gatherings, to keep the field vibrant and fresh.

If we look at works from so-called primitive cultures — African, Native American, Aboriginal — we notice that they often express what the artist finds in himself: the material is but a vehicle of expression. As Hap Sakwa explains, "The visual arts are a tradition of communication that began with our ancestors. The tradition has continued through the transformations all cul-

tures experience and remains the primary means through which humankind bears its soul." Our history is recorded in the objects of art and design we create.

When content is added to craft, questions beyond form and function must be considered. As we look back through history, we note that woodworkers today are just continuing the tradition of expressing culture through the sheer beauty of line and color. We are enveloped in color and texture every day; they influence how we function in our lives.

In other media, color is used as a natural design component, offering a full palette with which to explore. The introduction of color to wood expands our concepts of design; it allows the artist, not the material, to control the aesthetic outcome.

Craft artists maintain a reverence for traditions, and as we strive to create new traditions in our respective fields, we also strive to make work that moves us. As wood artists, we add life to our work — sometimes gently, other times controversially. In the end, it is not only the soul of the tree that reaches out to the viewer, but the soul of the artist as well.

Michael Hosaluk
Saskatoon, Saskatchewan, Canada

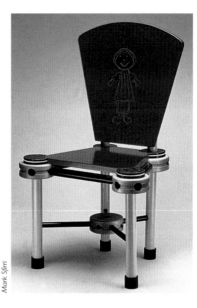

Mark Sfirri

LEFT: Joanne Shima, *Child's Chair,* 1987, maple and paint, 12" x 10" x 26."

MIDDLE: Liz and Michael O'Donnell, *Geometric Series,* 1981, sycamore, acrylic color and wood dye, 4.5"Dia. x 3.5" each piece.

BOTTOM: Wendell Castle, *Dr. Caligari's Desk,* 1989, mahogany, oak, mahogany veneer, ebony veneer, silver-plated brass and leather, desk: 29.75" x 80" x 38"; chair: 32" x 18" x 22".

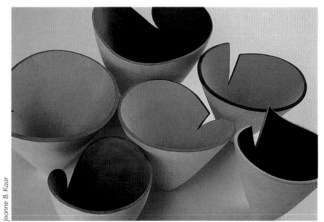

Joanne B. Kaar

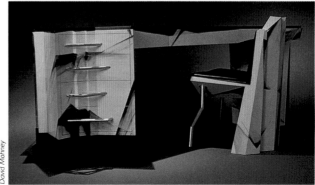

David Mahney

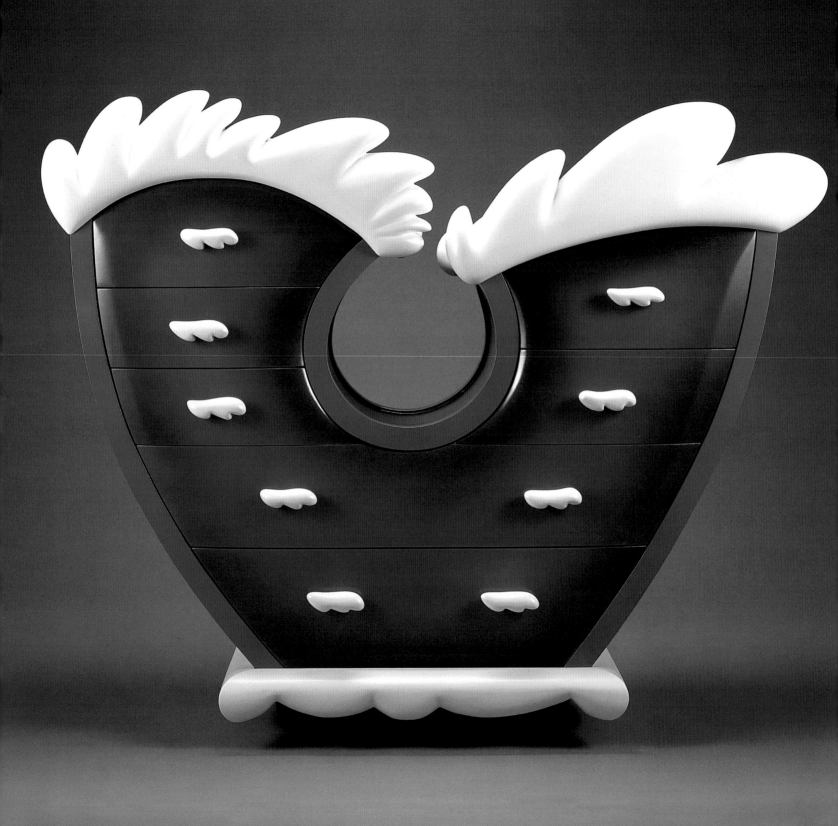

COLOR AND LINE

Koichiro Hayashi

Yuko Shimizu, *White CD Tower* (detail), 1999, mahogany,
maple, milk paint, acrylic and dye, 78" x 22" x 14".

By adding color to wood, the artist can cover, subdue or emphasize the wood's inherent qualities; the right balance of effects creates a marriage of patterns between wood and color that wood alone cannot achieve.

The wood surface is used to convey ideas no differently than canvas or paper. Like paintings, decorated surfaces engage the viewer and provoke the imagination. Artists can arrange lines to suggest volume and illusion, to isolate form and balance. Lines may be straight or irregular, and awkward perspective can enhance the work.

Artists have created a new palette of thinking in the creation of art on wood, and objects evoke new meaning with the introduction of dimension and interaction. As varied as the palette is, so too are the artists and their philosophies of making art objects. Wood artists today are engaged in new directions as innovative and exciting as any witnessed in history.

We use myriad processes to create our work; the hard part is finding that visual balance. When achieved, the ideas are conveyed through a visual language that can be understood by anyone. In this network of color, line and form, the artist's freedom of expression is captured and alive.

Richard Ford, *I Paint It Blue, Baby,* 2000, polychromed poplar, 75" x 50" x 20". "My work illustrates two concepts: utility and humor. By using a widely recognizable format — furniture — and instilling my pieces with wit and visual outrageousness, I am able to speak to a greater audience. In addition, by adding a level of utility, I create a stronger connection with the viewer. My pieces aren't finished until they become part of someone's environment."

Bill Bachuber

Gavin O'Grady

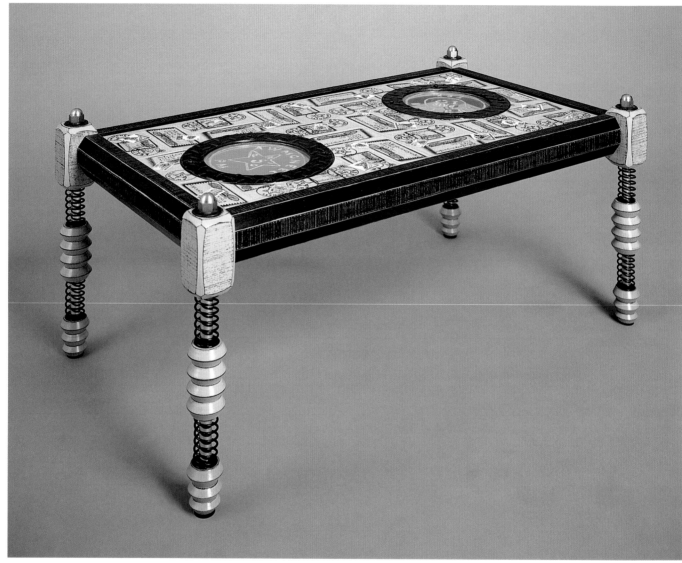

Ken Von Schlegell

TITLE: Spring Table, 1995

DESCRIPTION: Painted mahogany, stainless steel, springs, glass and steel

DIMENSIONS: 17" x 41" x 23.5"

"I create furniture and related objects that incorporate traditional furniture-making techniques with refunctioned materials: photographs, graphic images and other surface embellishments used as vehicles of meaning." — Gavin O'Grady

Tom Loeser

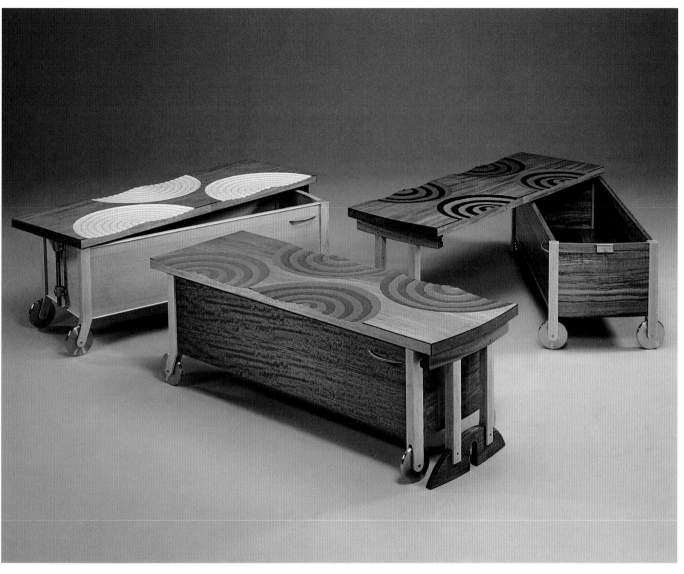

Bill Fritsch

TITLE: Roller Benches, 2001

DESCRIPTION: Painted mahogany, fir, maple, olive, koa, steel and stainless steel

DIMENSIONS: 20" x 20" x 58" each

"I see color and surface design as tools for helping the viewer 'read' the object. I love experimenting with color and surface. I am particularly interested in finding just the right color relationships to bring an object to life. For the *Roller* blanket chests, I combined smaller painted sections with natural wood. The painted sections clarify the seating areas. I was thinking about tractor seats and how invitingly and directly they identify just where you are supposed to put your rear." — Tom Loeser

Leon Lacoursiere

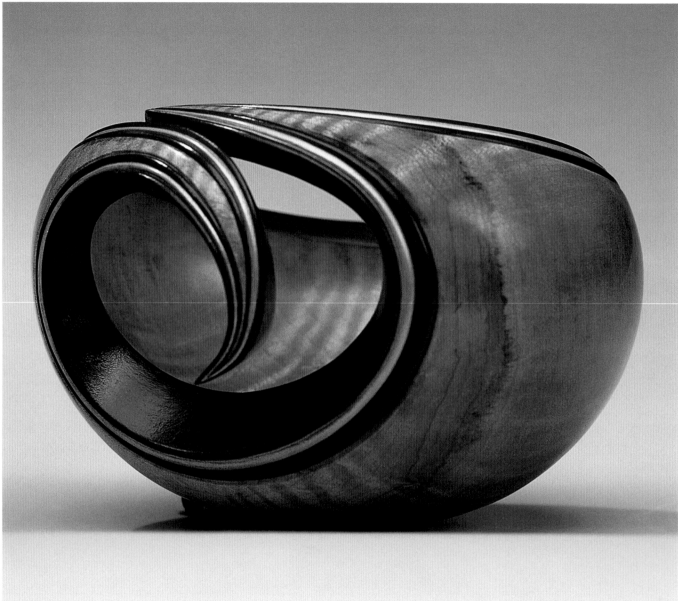

Grant Kernan

TITLE: Bowl

DESCRIPTION: Curly maple and acrylic paint

DIMENSIONS: 6" x 6" x 4"

"I strive for simplicity of line and form. I like to combine ideas from jewelry, turning, carving and painting to accentuate the beauty of the wood."— Leon Lacoursiere

Stephen Hogbin

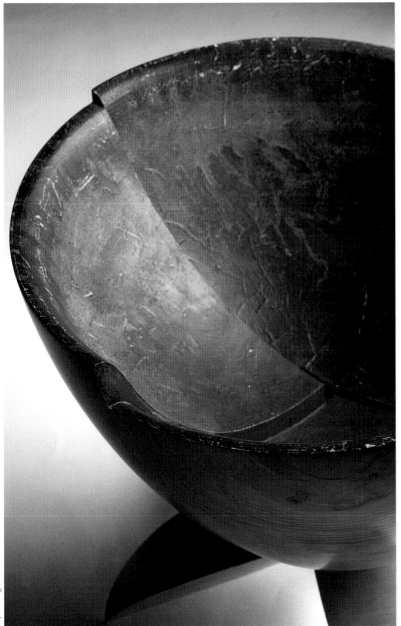

Stephen Hogbin

TITLE: Purple Red Bowl, 2001

DESCRIPTION: Wood and paint

DIMENSIONS: 11"Dia.

"Wood is an appropriate medium to receive paint and color.
The surface may become complex, subtle or textured,
developing depth that draws the eye into the piece. There is a
playfulness in contemporary painted wood. The bright colors
have a carnival atmosphere and the designs are often humorous
and fantastic. I prefer the subtlety and complexity that the
hand-with-brush finish generates." — Stephen Hogbin

Betty Scarpino

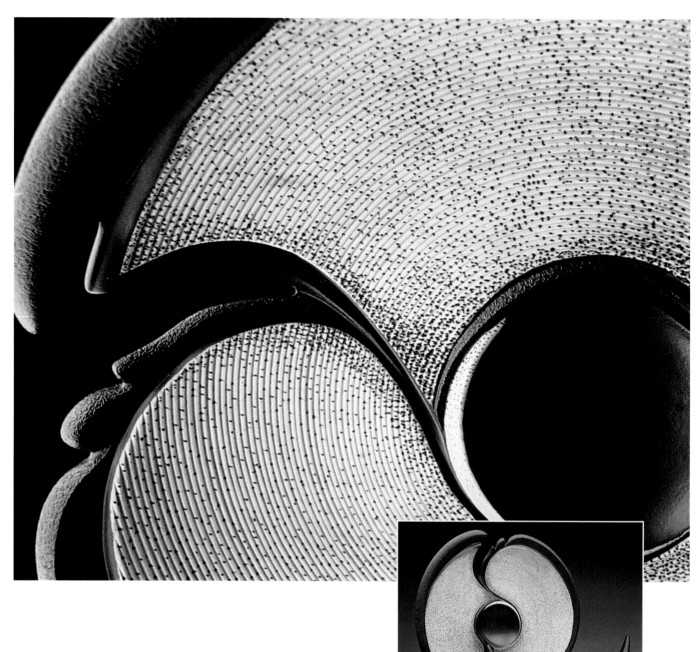

TITLE: Stepping Out of Line, 1991

DESCRIPTION: Maple, turned, carved, bleached,

ebonized, textured and stippled with graphitel

lacquer

DIMENSIONS: 11"Dia

Photos: Judy Ditmer

Hayley Smith

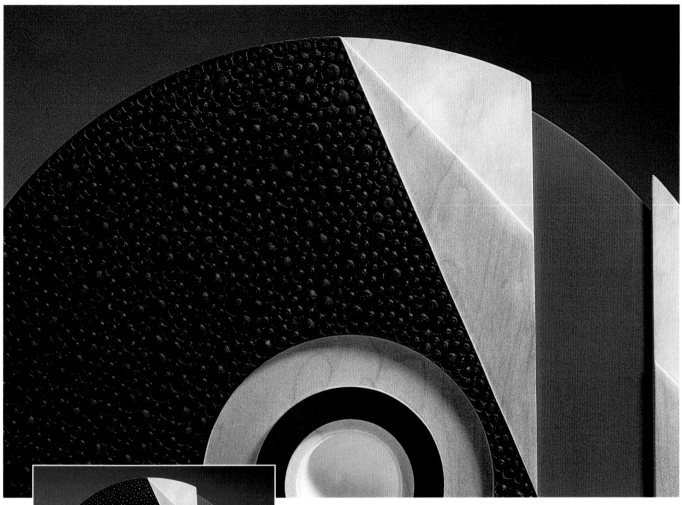

Photos: Hayley Smith

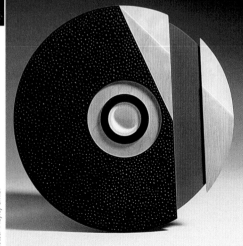

TITLE: Bebop, 2001

DESCRIPTION: Sycamore

DIMENSIONS: 10.4"Dia. x 1"

"The circle in all its forms — turned or carved, concentric or subdivided — reflects the patterns of our lives and the world. The central bowl or hole is the space within which I dwell. I strive to create a harmonious whole. My work allows me to reflect upon my life and my relationship with the world I live in." — Hayley Smith

Cory Robinson

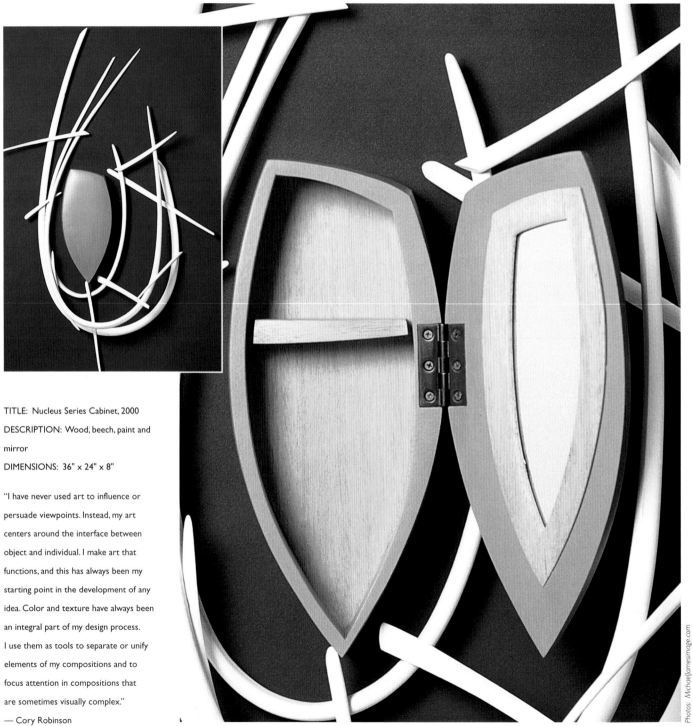

TITLE: Nucleus Series Cabinet, 2000

DESCRIPTION: Wood, beech, paint and mirror

DIMENSIONS: 36" x 24" x 8"

"I have never used art to influence or persuade viewpoints. Instead, my art centers around the interface between object and individual. I make art that functions, and this has always been my starting point in the development of any idea. Color and texture have always been an integral part of my design process. I use them as tools to separate or unify elements of my compositions and to focus attention in compositions that are sometimes visually complex."

— Cory Robinson

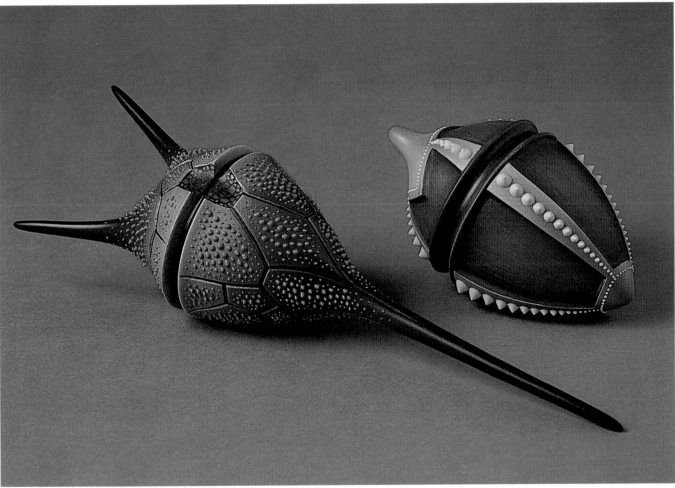

Frank Youngs

TITLE: Dinoflagellate Boxes I and II, 2000

DESCRIPTION: English sycamore, ebony, yew, acrylic ink,

polyester resin and acrylic texture paste

DIMENSIONS: 10.4" x 4.9"Dia.

"I have always been inspired by the natural world, particularly marine life,

microscopic creatures, plants and fossils. Together they offer a fantastic repertoire of

imagery. Each of my pieces originates on the lathe. I often use carving, airbrushed

inks, colored waxes, scorching, resin or metal to create the effects that I require."

— Louise Hibbert

Dewey Garrett

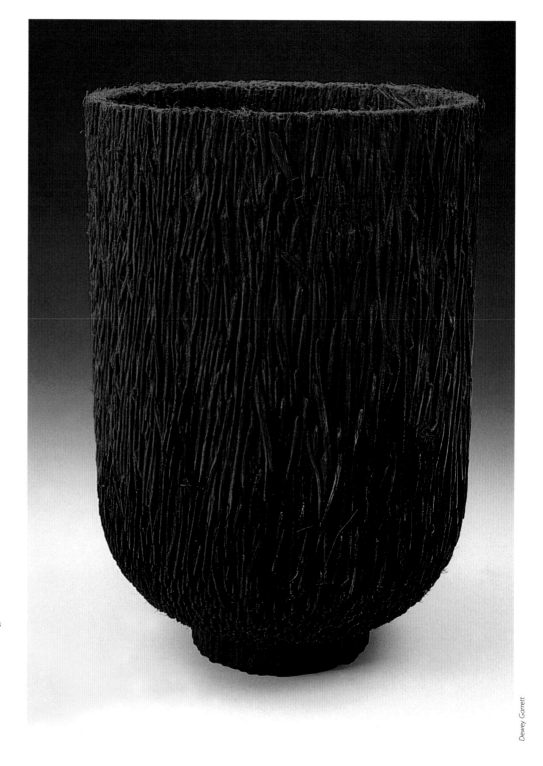

Dewey Garrett

TITLE: R and B, 1997

DESCRIPTION: Palm wood,
turned and dyed in red and black

DIMENSIONS: 13.5" x 8"

"I am interested in the transformation and
contrast discovered through wood turning.
The process of converting featureless blocks
of wood into graceful, symmetrical forms
is always fascinating and full of surprises.
The addition of dyes and patinas alters the
natural appearance of the wood and can
either subdue or emphasize its inherent
organic character." — Dewey Garrett

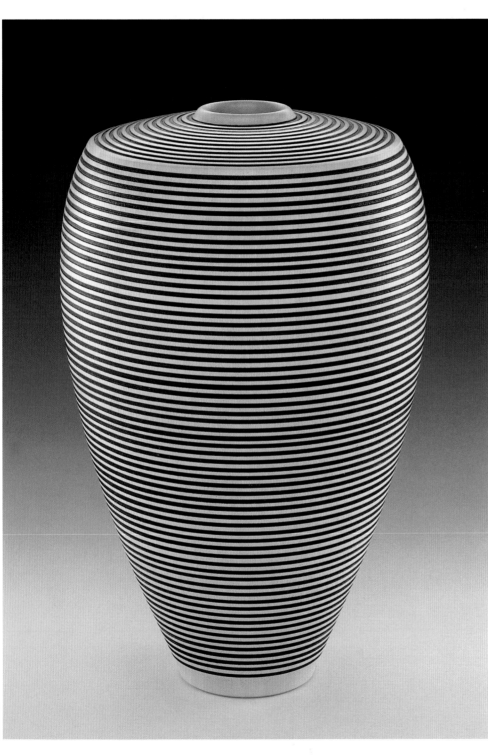

John Jordan

Bruce Miller

TITLE: Untitled, 1993
DESCRIPTION: Bleached box elder
and acrylic paint
DIMENSIONS: 9.5" x 6"Dia.

"During the mid-1990s, most of my pieces
were either black or white, concentrating
on form and surface rather than the wood."
— John Jordan

Christian Burchard

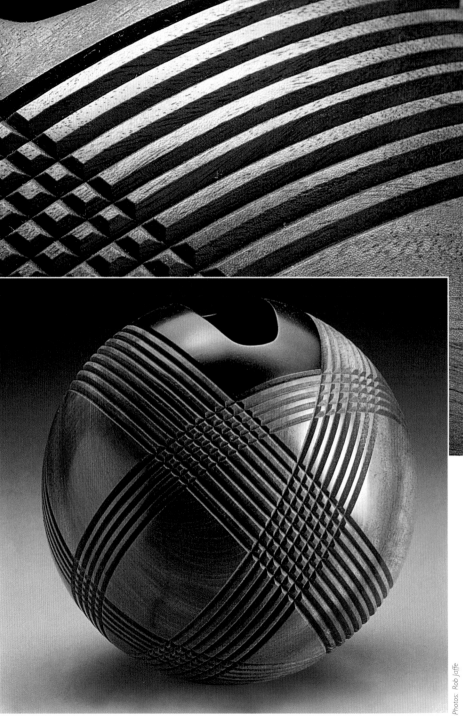

TITLE: Old Earth Series, 1995

DESCRIPTION: Cuban mahogany and black ink

DIMENSIONS: 8"Dia. x 8"H

"I feel that it is very important that any texturing or surface design becomes integrated into the overall design of the work. I also feel that the more you work the surface, the quieter the material has to be." — Christian Burchard

Photos: Rob Jaffe

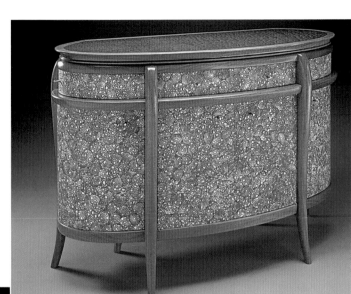

TITLE: Java Credenza, 2001

DESCRIPTION: Mahogany, pommele

sapele and polymer clay veneer

DIMENSIONS: 56" x 24" x 38"

"With this credenza, we were reflecting on some of the exotic materials
used in Deco furniture as we created a marriage of the woods and the
polymer clay veneers. We tried to create an organic pattern in the clay,
almost like shells or animal spots, with a scale and repeat in pattern that
echoed the figure in the wood, and colors that harmonized."

— J.M. Syron and Bonnie Bishoff

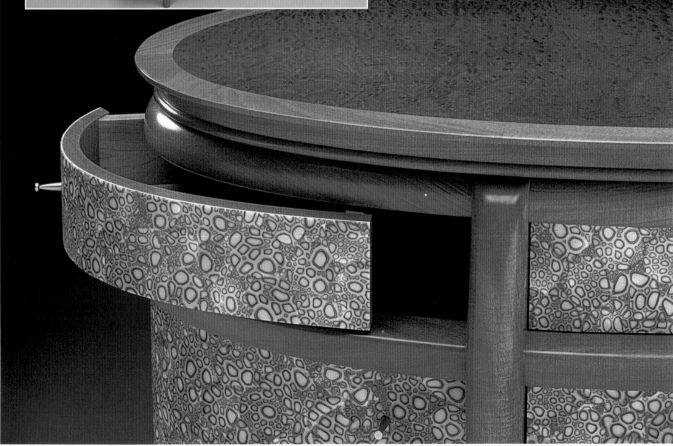

Photos: Dean Powell

Tom Loeser

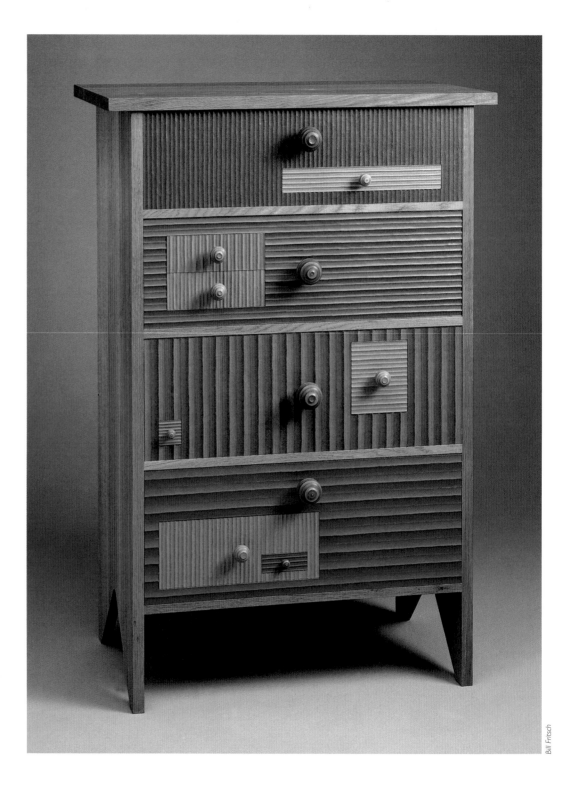

TITLE: Multiple Complications,
1995
DESCRIPTION: Painted
mahogany and oak
DIMENSIONS: 50" x 34" x 21"

"The structural concept of the
Multiple Complications chests
involves drawers within drawers,
so that the internal and external
forms become fairly complicated."
—Tom Loeser

Bill Fritsch

Michael Cullen

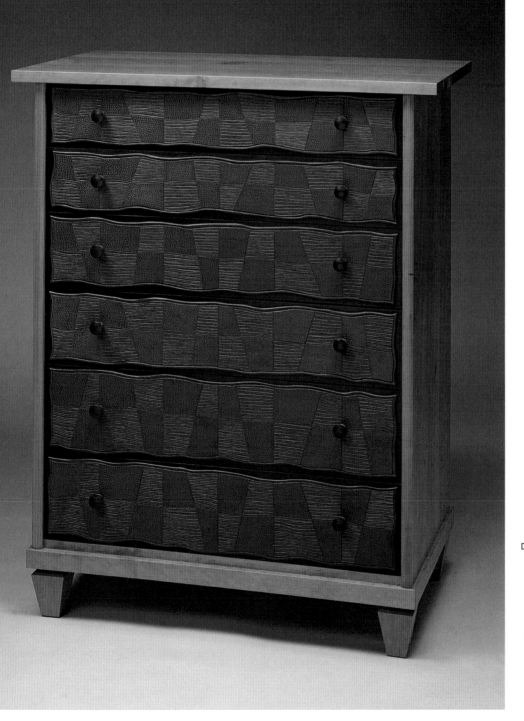

Don Russell

TITLE: Chest of Drawers, 2000

DESCRIPTION: Milk paint,
cherry, maple, tung oil,
and pulls of grenadillo

DIMENSIONS: 46" x 36.5" x 21.75"

"I designed the chest to look
straightforward and elegant, so
that the carving would play the
primary role. One thing I really like
about this piece is how well the
combination of color, carving and
natural wood works together."

— Michael Cullen

John Cederquist

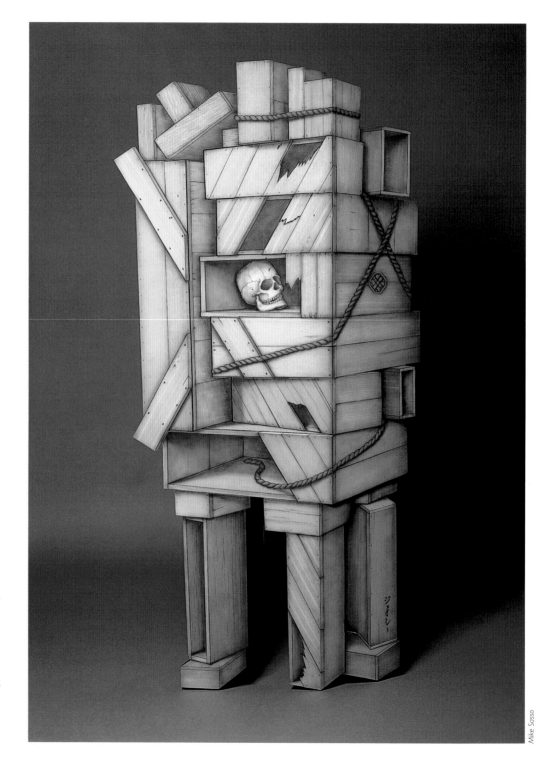

TITLE: *Cajon de los Muertos*, 1995
DESCRIPTION: Birch plywood, Sitka spruce, maple, aniline dye and epoxy resin
DIMENSIONS: 85" x 45" x 14"

"What begins as form soon veers into image, while function itself occupies a narrow space between surface and depth, between reality and illusion — a place called 'two-and-a-half dimension.'"
— John Cederquist

36

Mike Sasso

Michael H. de Forest

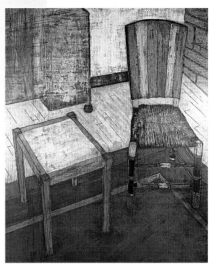

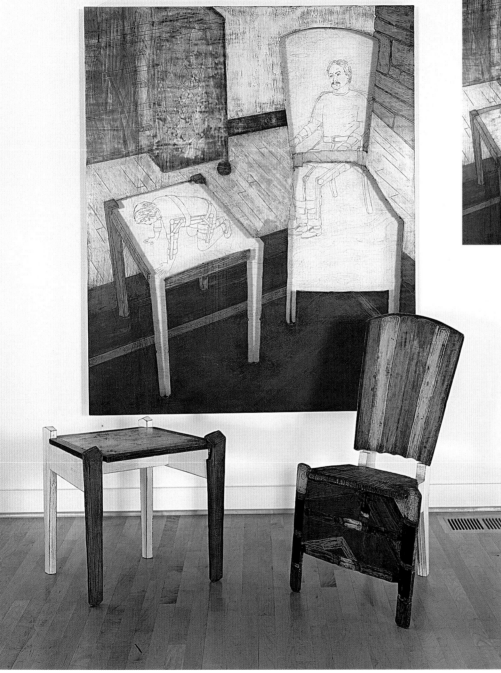

Photos: Phil Harris

TITLE: Michael's Chair, 2000
DESCRIPTION: Birch plywood,
incised line carving and milk paint
DIMENSIONS: 67.75"
x 56.5" x 2.75"

"Furniture, being an intimate
medium, can present itself as a
jarring and penetrating vehicle
to explore our conditions, values,
horrors and dreams. Here, the
images of the chair and table can
be taken out of the face of the box
and attached to additional legs
and braces stored inside.
When the chair and table images
are removed, portraits of me as a
table and chair are exposed."
— Michael H. de Forest

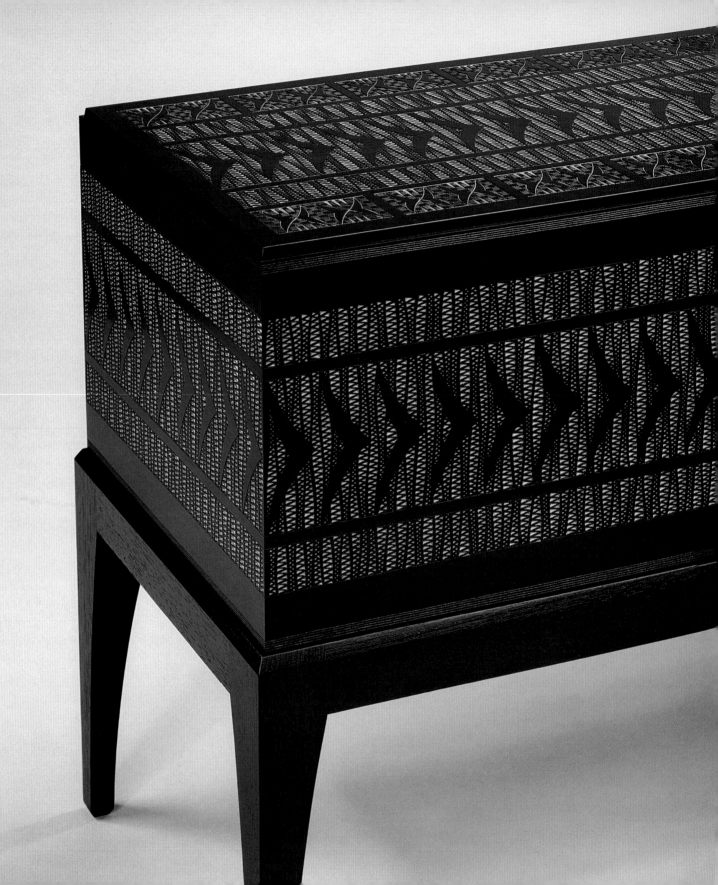

MAKING MARKS

Joe Chielli

Peter Pierobon, *Vice Versa*, 2000, milk paint on mahogany, 40" x 40"x 3".

A child scribbling. Our doodles on a shopping list. The rapid pattern created by a chain saw. The quiet serenity of a well-honed carving tool as it slips through the wood fiber. These repeated patterns convey a sense of personal history and ceremony.

While I was conducting a public demonstration, carving patterns on a blackened vessel, a woman walked up to me and asked if I was Ukrainian. I thought it quaint and asked why she wanted to know. She remarked that she had worked in a museum and that the marks I had made were identical to ones she had seen on old Ukrainian pottery. It made me realize that humans as a species are archetypal. When we unleash our subconscious and shed our inhibitions, we make marks that parallel those of other civilizations and cultures throughout history.

Our marks, patterns and patinas become integral to the overall design of our work, and when we work from our intuitive nature, the designs we make leave evidence of ourselves. Each artist uses his or her own methods and formulas, and each benefits from happy accidents along the way, where some uncontrollable factor alters the original intention for the better. A seemingly inconsequential mark might spark an idea that leads to a whole series of works. We never make mistakes; we just create design opportunities.

Kristina Madsen, *Blanket Chest,* 1995, maple, dyed pear wood veneer and wenge, 23.5" x 51" x 15".

Robyn Horn

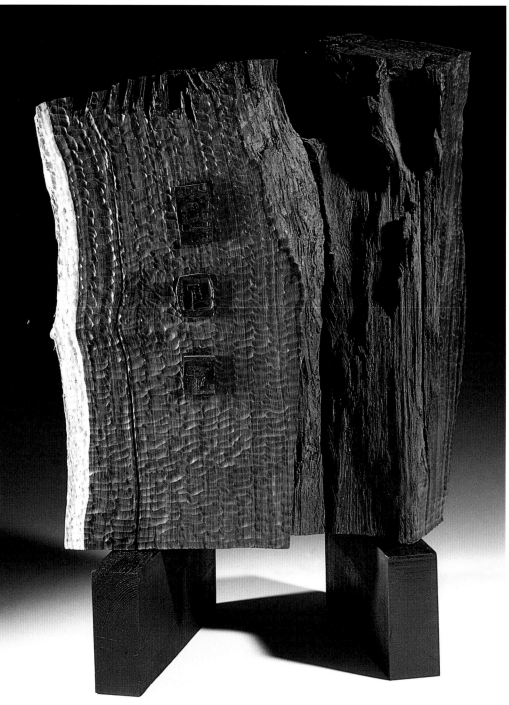

TITLE: Intersecting Slabs, 2001
DESCRIPTION: Cocobolo and metal
DIMENSIONS: 32" x 34" x 20"

"This work was made from a single
piece of cocobolo, with cuts made into
the wood to suggest that two slabs
have intersected. The suggestion goes
further, to indicate that the metal
medallions go through the slabs and
bind them together. The blocks holding
the piece give it an industrial, stacked
look and an elevated presence."
— Robyn Horn

Sean Moorman

Michael Lee

Photos: Hugo De Vries

TITLE: Dancing in the Moonlight, 2001
DESCRIPTION: Cocobolo
DIMENSIONS: 8" x 8" x 4"

"My work begins with a mental image. That image is
transformed to a physical reality through a combination
of curves, surfaces, textures and a sense of surrealism.
My hope is that the piece will speak through its own
visual and tactile language." — Michael Lee

41

Jacques Vesery

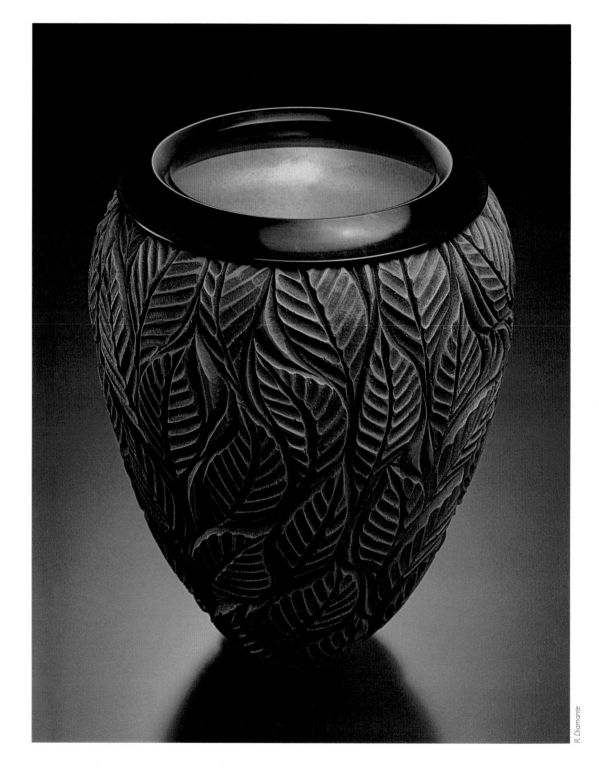

TITLE: *Eveillé et le Rêve*
(Awake and Dreaming), 2001
DESCRIPTION: Carved
cherry, ebony and 23.5K
French gold leaf
DIMENSIONS: 5.5"Dia. x 4"

R. Diamante

Stephen Hughes

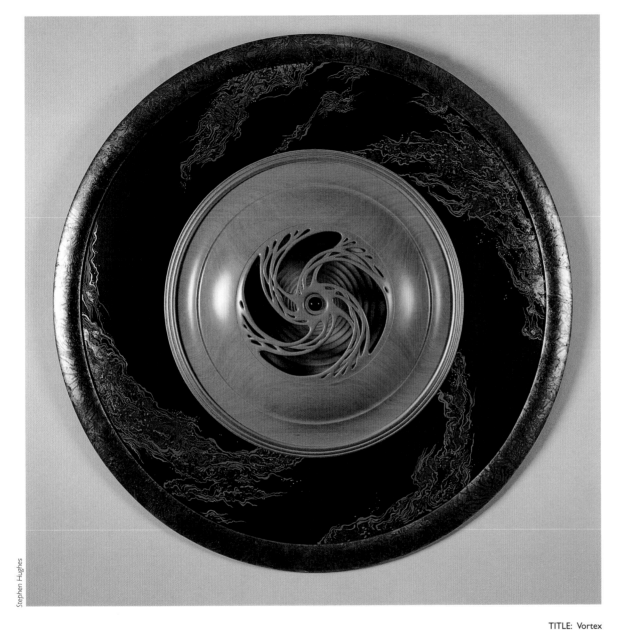

Stephen Hughes

TITLE: Vortex

DESCRIPTION: Huon pine, red gum, acrylics and copper leaf

DIMENSIONS: 47.2"Dia. x 4.7"

"I combine pierced and carved surfaces in my work, and the ideas for
these are mainly focused on mystical themes." — Stephen Hughes

Randy Shull

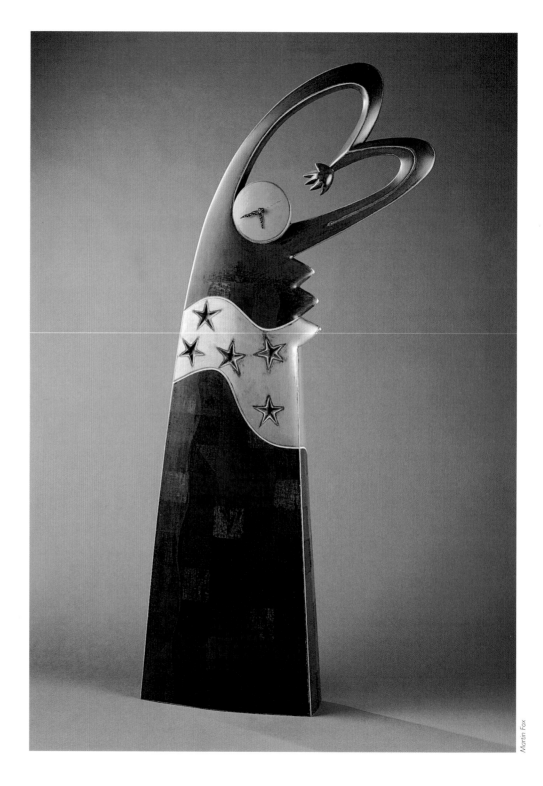

TITLE: Cobalt Dream, 1995

DESCRIPTION: Painted wood

DIMENSIONS: 80" x 36" x 10"

"This piece makes reference to the notion that tall clocks are figurative. In this case I was looking at my girlfriend doing yoga stretches and decided to use her pose as a gesture for this clock. So instead of a grandfather clock, we have a girlfriend clock." — Randy Shull

Martin Fox

Tommy Simpson

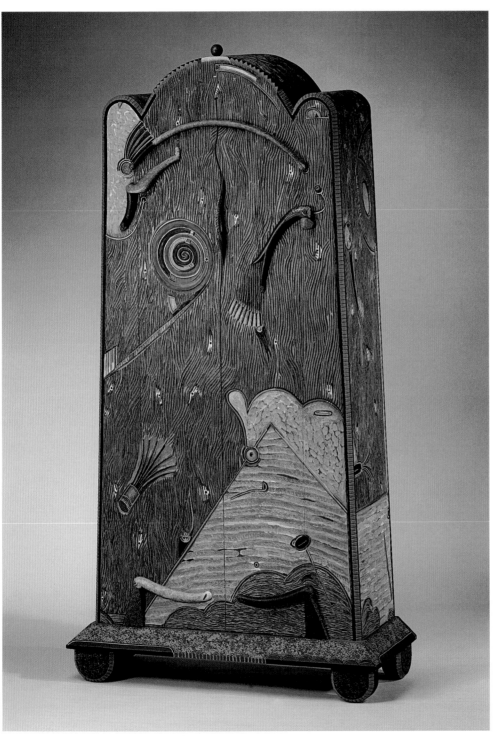

William Seitz

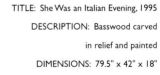

TITLE: She Was an Italian Evening, 1995
DESCRIPTION: Basswood carved
in relief and painted
DIMENSIONS: 79.5" x 42" x 18"

"She was sheaved in hot colors,
with only the slightest hint of
those luscious shelves reclining
on the inside." — Tommy Simpson

45

Michael Cullen • Kim Kelzer

ARTIST; Kim Kelzer

TITLE: Poodle Bench, 2001

DESCRIPTION: Mahogany, maple, paint and Shaker tape

DIMENSIONS: 21.5" x 44" x 15"

"Objects are made like sausages; you may really enjoy the end product, but you might not want to see what goes into them or watch them being made." — Kim Kelzer

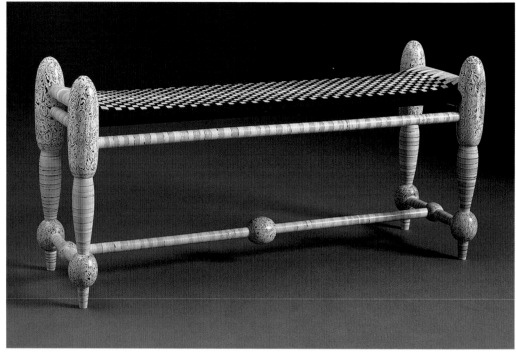

Rachel Olson

ARTIST: Michael Cullen

TITLE: Treasure Chest #2, 1996

DESCRIPTION: Mahogany, milk paint, nutmeg and shellac

DIMENSIONS: 22" x 9.5" x 10"

"My intent was to create a pattern and texture that appear both spontaneous and alive."
— Michael Cullen

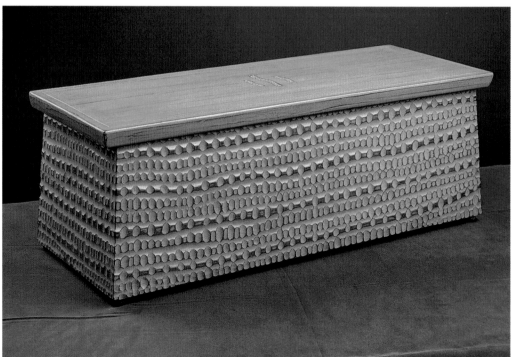

John McDonald

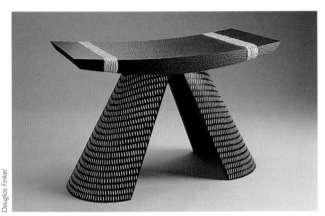

Douglas Finkel

ARTIST: Douglas Finkel

TITLE: Source Bench

DESCRIPTION: Poplar, paint and rope

DIMENSIONS: 17" x 12" x 27"

"Through its detailed surface treatment, *Source Bench* evokes a variety of moods. It has been sandblasted, wire brushed, adorned with rope and cloth, finished naturally, painted, carved and hammered." — Douglas Finkel

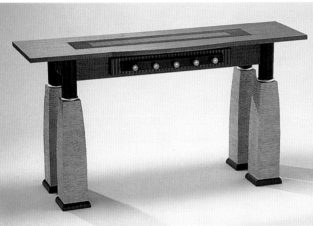

Koichiro Hayashi

ARTIST: Yuko Shimizu

TITLE: Table One, 2000

DESCRIPTION: Mahogany, poplar, milk paint, maple, acrylic paint and black dye

DIMENSIONS: 33" x 22" x 21"

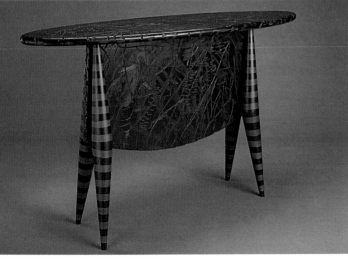

John Lucas

ARTIST: Graham Campbell

TITLE: Hall Table, 1998

DESCRIPTION: Painted ash and medium-density fiberboard

DIMENSIONS: 14" x 48" x 35"

"This extremely bland material [the fiberboard] was given visual weight by scoring the surface and painting it. The legs were animated with color and contrast." — Graham Campbell

Graham Campbell • Yuko Shimizu • Douglas Finkel

47

Rosanne Somerson

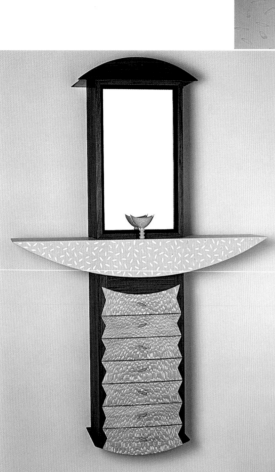

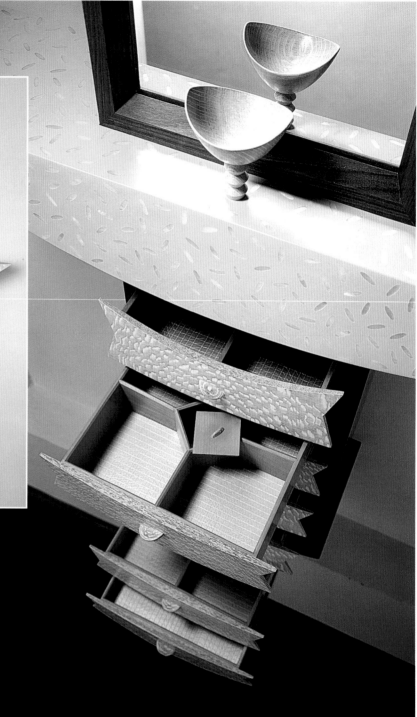

TITLE: Vanity, 1991

DESCRIPTION: Pau ferro, bleached leopard wood, pear
wood, mirror, handmade paper and mother-of-pearl

DIMENSIONS: 49" x 32" x 11"; drawers: 5.5" x 16" x 11"

"When I incorporate a surface that I have created, I am
keenly aware of how it will interact with the beauty of the
natural surface. The dialogue between the two adds
a dynamic quality that I try to make work as a whole."

— Rosanne Somerson

Photos: Dean Powell

48

Peter Pierobon

Joe Chielli

TITLE: Time Piece, 2000

DESCRIPTION: Mahogany and milk paint

DIMENSIONS: 78" x 23" x 20"

"The surface of my work is overrun with tool
marks and symbols. Each piece is at once a
document of its own making and an attempt to
communicate an idea, message or concept."
— Peter Pierobon

49

Mark Gardner

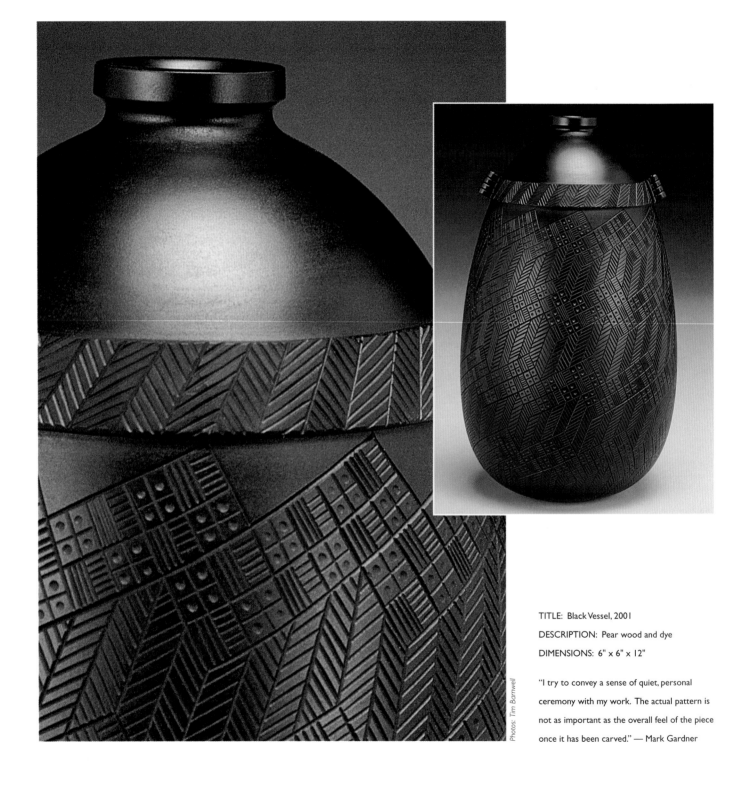

Photos: Tim Barnwell

TITLE: Black Vessel, 2001

DESCRIPTION: Pear wood and dye

DIMENSIONS: 6" x 6" x 12"

"I try to convey a sense of quiet, personal ceremony with my work. The actual pattern is not as important as the overall feel of the piece once it has been carved." — Mark Gardner

Ron Fleming

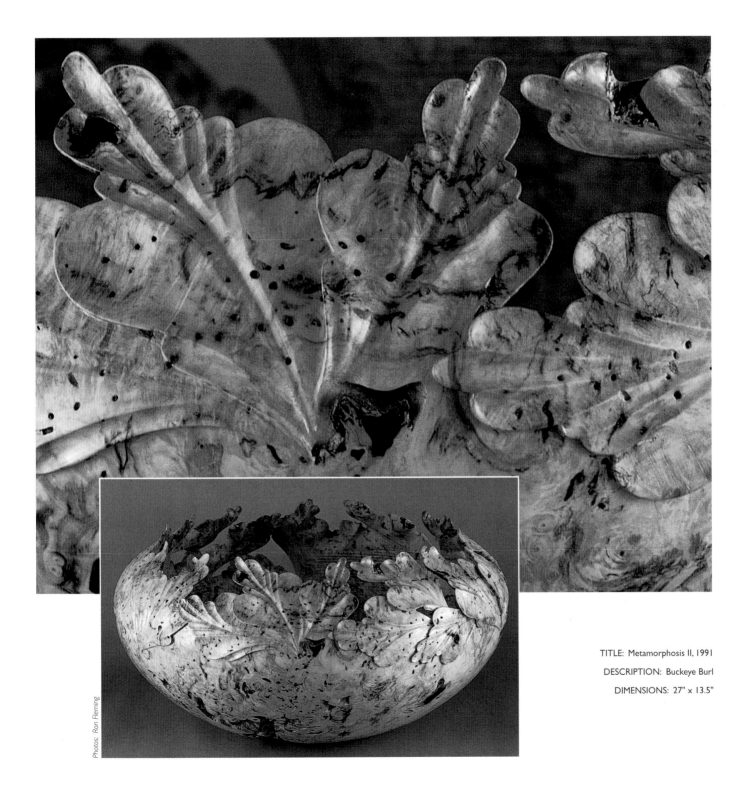

Photos: Ron Fleming

TITLE: Metamorphosis II, 1991

DESCRIPTION: Buckeye Burl

DIMENSIONS: 27" x 13.5"

Alan Stirt • Clay Foster

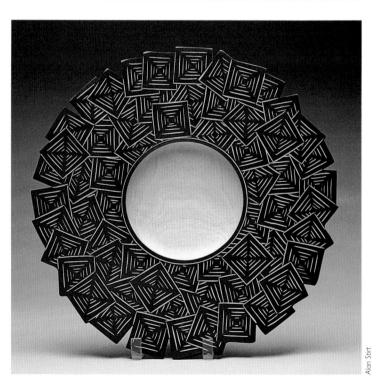

Clay Foster

ARTIST: Clay Foster

TITLE: Black and White Vessel, 1998

DESCRIPTION: Hackberry and printer's ink

DIMENSIONS: 18" x 6"

"There is a rhythm and pattern to life, a cadence, a suspending and preserving of the beat. The pattern evolves, but the rhythm continues, as we work our way upward through life. The patterns and rhythms are what help us keep our balance." — Clay Foster

ARTIST: Alan Stirt

TITLE: Crowded Square, 2001

DESCRIPTION: Sugar maple and paint

DIMENSIONS: 15"Dia.

"I was intrigued by the frantic energy generated by the converging squares, in contrast to the peaceful center." — Alan Stirt

Alan Stirt

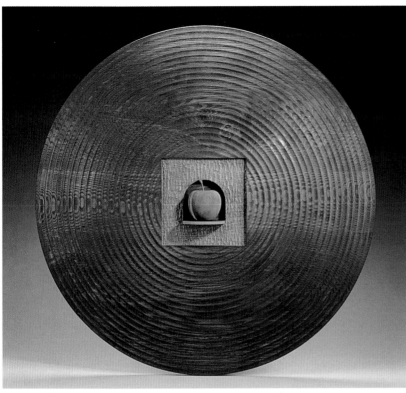

Hap Sakwa

ARTIST: Merryll Saylan
TITLE: Forbidden Fruit, 2001
DESCRIPTION: Ash and maple
DIMENSIONS: 2" x 27"Dia.

"My environment has always affected my work. I live next to a salt marsh, and the movement and patterns resulting from tidal action are reflected on my surfaces." — Merryll Saylan

ARTIST: Jacques Vesery
TITLE: Easy Winds, 2001
DESCRIPTION: Cherry and cherry burl
DIMENSIONS: 2" x 6"Dia.

"There is a dichotomy between elegance and rustic nature which can be hard to understand. Smooth surfaces, rough textures, brilliant and deep dark tones become one. Light dances across the multifaceted surfaces. Yet, there is a sense of energy in the sharpness that needs to be touched and is hard to put down."
— Jacques Vesery

Jacques Vesery • Merryll Saylan

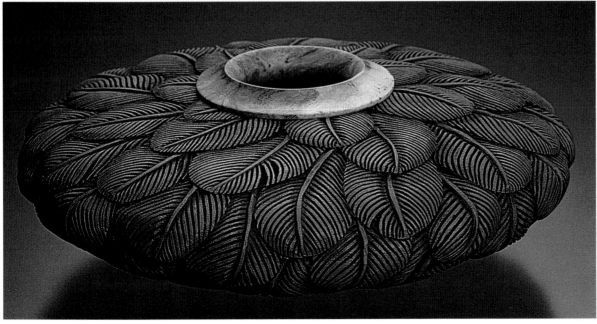

R. Diamante

David Ellsworth

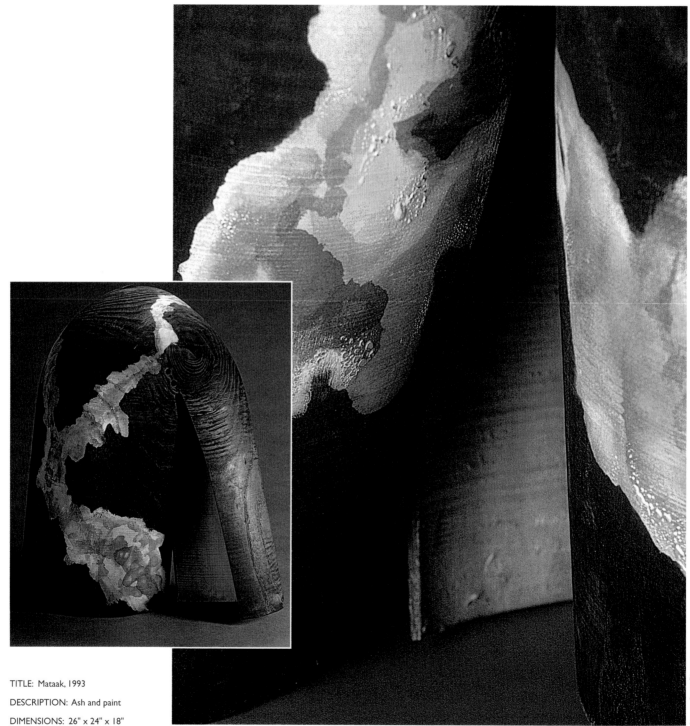

TITLE: Mataak, 1993

DESCRIPTION: Ash and paint

DIMENSIONS: 26" x 24" x 18"

Photos: David Ellsworth

54

Jack Larimore

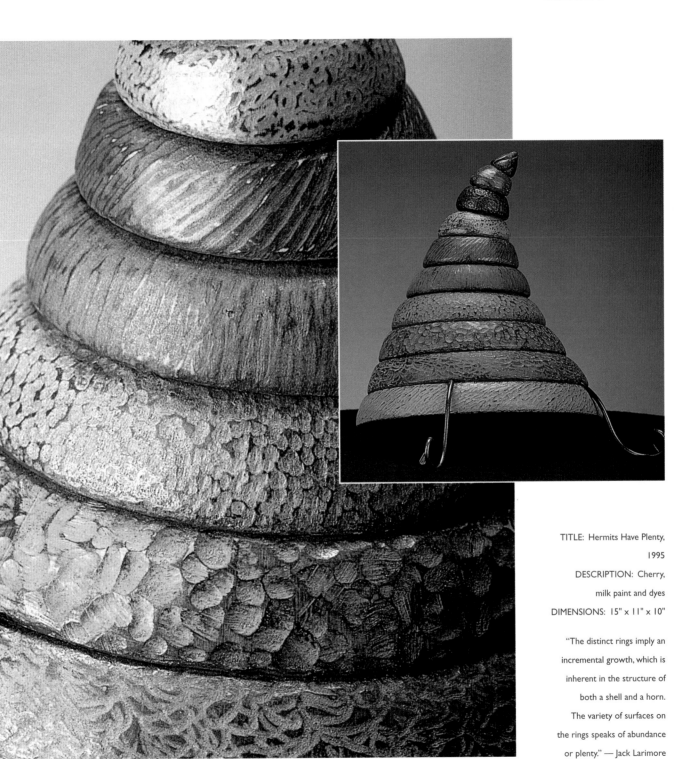

TITLE: Hermits Have Plenty,
1995
DESCRIPTION: Cherry,
milk paint and dyes
DIMENSIONS: 15" x 11" x 10"

"The distinct rings imply an
incremental growth, which is
inherent in the structure of
both a shell and a horn.
The variety of surfaces on
the rings speaks of abundance
or plenty." — Jack Larimore

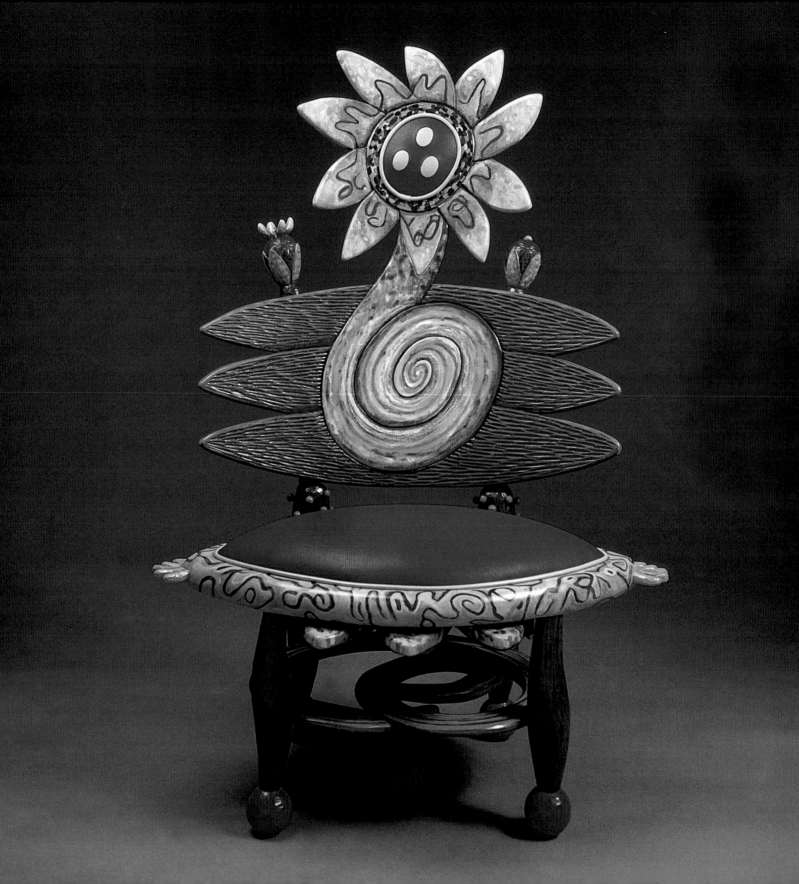

FUN AND HUMOR

Paul Sasso, *Blame It on Plato,* 2001, bass-
wood, maple, magnolia, 8.5" x 9" x 13.5".

It's important to have fun in life. If you add humor and laughter to the equation, you are doing all right, no matter what you are doing. When we make things that are fun, we let imagination range beyond reality. We can take everyday objects and present them in a different light. The forms can be awkward, imperfect or abstract, in the same ways that people are. The work may come across as humorous, initially, but layers of meaning lie below. It is our way of expressing the ideas we have with humor.

We construct art that finds importance in material and conveys meaning in narrative. This is done with a reverence for the past, while often using humor to comment on the present. By using color, the artist can be more expressive in the mood or message he conveys. A deep patina or vibrant image can be projected with clarity and purpose.

We all have fun in different ways. We function within a frame of reference that we construct for ourselves, extracting images from the silly, absurd or incongruous aspects of our lives and culture.

Kathie Johnson and Rob Gartzka, *Joy Springs,* 1999, polychrome wood and leather, 45" x 31" x 23". "The surface of our furniture is an exploration of color and texture. Smooth passages are in direct contrast to highly carved areas. We emphasize the carving by brushing multiple layers of paint. We allow the work to change as the creative process evolves. It is our hope that the paint appears as an integral aspect of the whole form.

Lowell Zercher

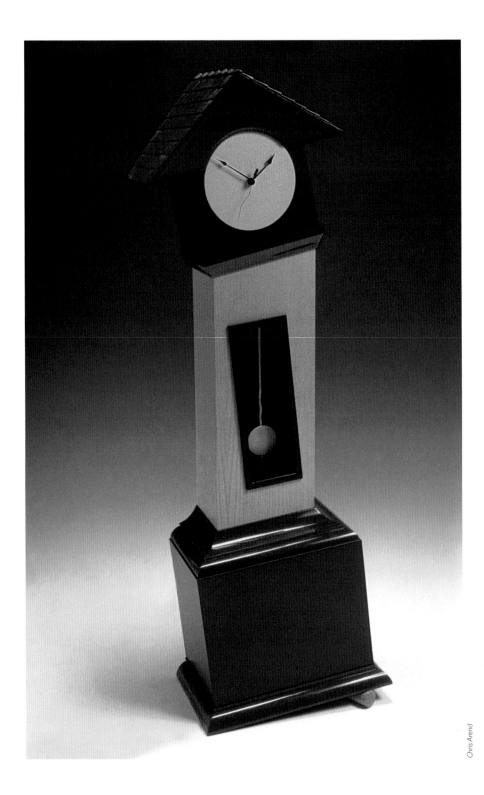

TITLE: There Was a Crooked Clock, 1995

DESCRIPTION: Wood, medium-density fiberboard, plywood, clock parts and paint

DIMENSIONS: 60" x 19" x 16"

"I find myself distracted by things in my surroundings. I investigate them, study the texture, make note of the color mix, study the form. All of this contributes to my repertoire; files in the brain resurface when triggered by a work in progress. The ideas are not necessarily aimed for the head, but often for the gut." — Lowell Zercher

Chris Arend

Craig Nutt

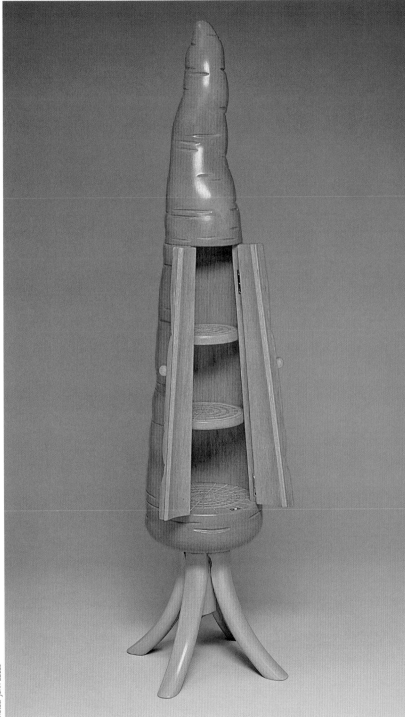

Photos: John Lucas

TITLE: Carrot Cabinet, 2000
DESCRIPTION: Oil paint on turned and carved wood
DIMENSIONS: 42" x 9" x 9"

"My work is concerned with function, both in a literal sense
and as an element to be played with, altered or skewed.
Whether expressed as furniture or sculpture, vegetables
have provided me with a visually and metaphorically rich and
evocative vocabulary. I remain committed to the furniture
form and, having established the idea of vegetable furniture,
continue to refine and enlarge the concept." — Craig Nutt

Garry Knox Bennett

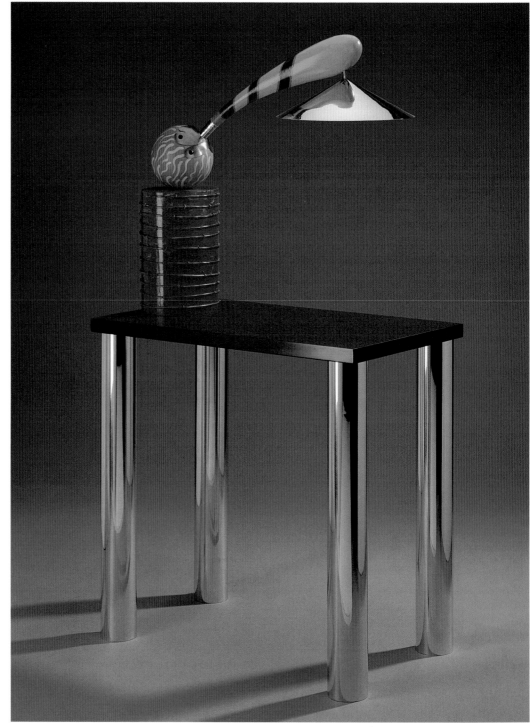

TITLE: Tablelamp #18, 2000

DESCRIPTION: Aluminum,

wood, ColorCore, lamp parts,

metal, paint and gold plate

DIMENSIONS: 55" x 18" x 30"

M. Lee Fatherree

Brad Reed Nelson

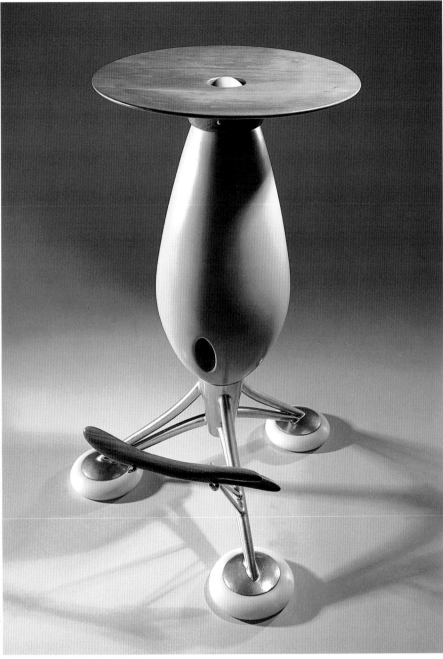

Alan McCuy

TITLE: Neither Here Nor There, Prickly Pear, 1998
DESCRIPTION: Basswood, cherry, Delren,
machined steel and Hydrocote finish
DIMENSIONS: 30" x 17" x 17"

"My furniture is a stylized remix of the qualities I find
alluring in today's pop culture." — Brad Reed Nelson

Michael Hurwitz

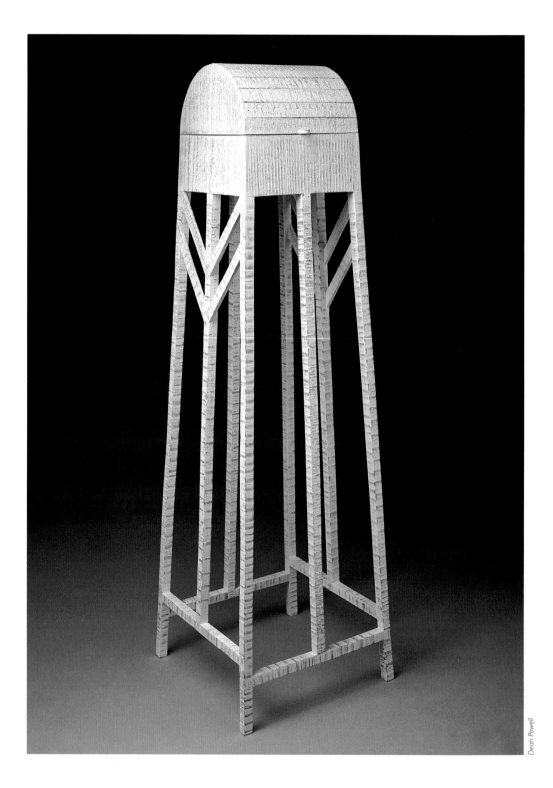

TITLE: Chest on Trees, 1985

DESCRIPTION: Mahogany and paint

DIMENSIONS: 48" x 14" x 14"

"I left the rhythm of the surface as it came off the saw and accentuated it with paint." — Michael Hurwitz

Dean Powell

Ed Zucca

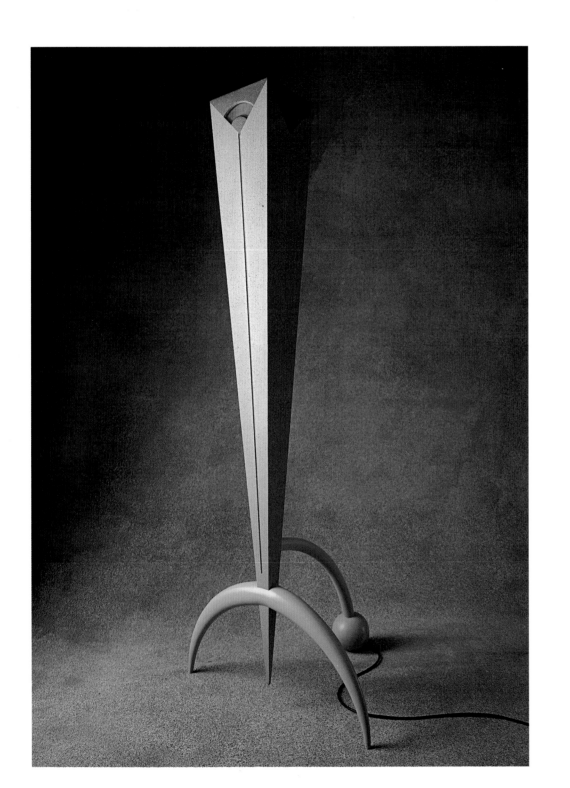

TITLE: Mario Lanza
Memorial Floor Lamp, 1983
DESCRIPTION: Poplar, maple, trunk
paint and 45 rpm red plastic record
DIMENSIONS: 84" x 30" x 24"

"Light shines through the recorded
voice of Mr. Lanza as he sings Verdi."
— Ed Zucca

David Ebner

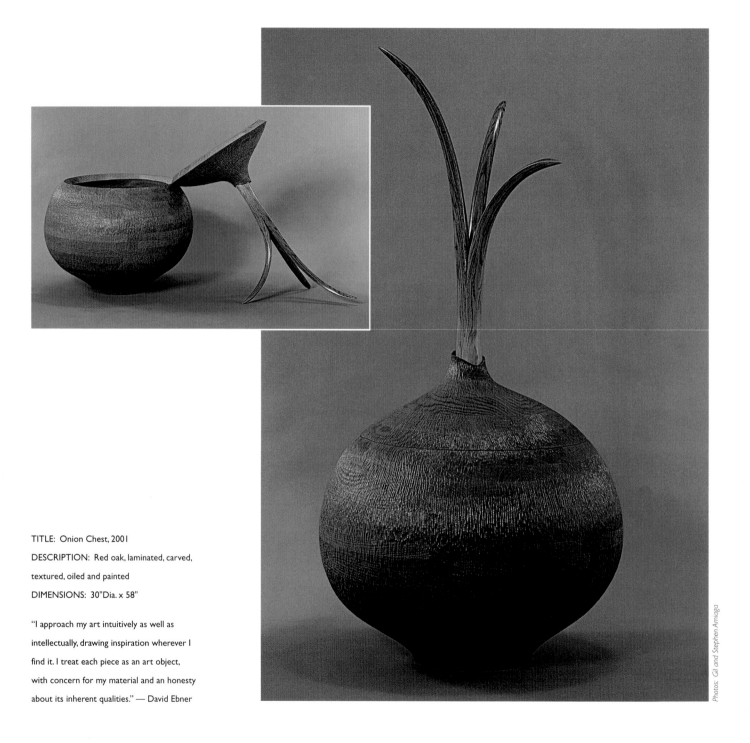

TITLE: Onion Chest, 2001

DESCRIPTION: Red oak, laminated, carved,
textured, oiled and painted

DIMENSIONS: 30"Dia. x 58"

"I approach my art intuitively as well as
intellectually, drawing inspiration wherever I
find it. I treat each piece as an art object,
with concern for my material and an honesty
about its inherent qualities." — David Ebner

Photos: Gil and Stephen Amiaga

Wendy Maruyama

TITLE: Shut Up and Kiss Me, 2000

DESCRIPTION: Polychrome jelutong, nails, wire and mirror

DIMENSIONS: 15" x 9" x 7"

"My work focuses on the emotional qualities of color and how that can contribute to furniture design. Color can make a piece dance in a way natural wood surfaces cannot duplicate." — Wendy Maruyama

John McNaughton · Frank Sudol

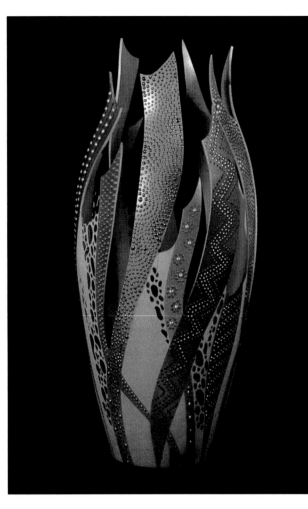

Frank Sudol

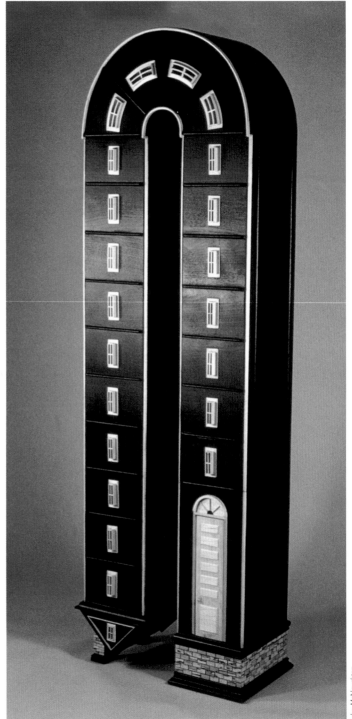

John McNaughton

ARTIST: Frank Sudol

TITLE: Birthday Streamers, 1999

DESCRIPTION: Birch, acrylic and dyes

DIMENSIONS: 10" x 4.3"

ARTIST: John McNaughton

TITLE: House on Its Head, 1998

DESCRIPTION: Hard maple and ebonized maple

DIMENSIONS: 72" x 24" x 16"

"This was fantasy architecture that moved into the realm of functional cabinets."
— John McNaughton

Lynn Sweet

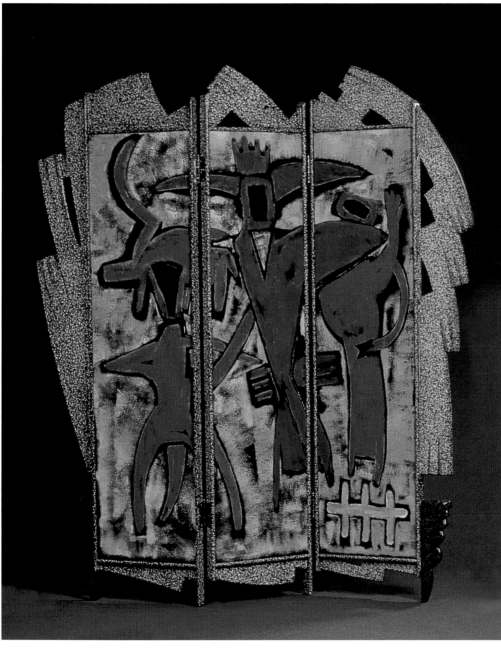

Photos: Lynn Sweet

TITLE: Rodney's Rhumba, 1995
DESCRIPTION: Acrylic polychrome on
carved and constructed hardwood
DIMENSIONS: 72" x 60"

"The visual power of an object depends
on its form, its surface and the program
in which these components interact.
My investigation of color stems from a
fascination with the effects of weathering
on signage, empty houses and abandoned
pickups. I express this through eroding
layers of artists' pigments on wood
substrates." — Lynn Sweet

Hap Sakwa

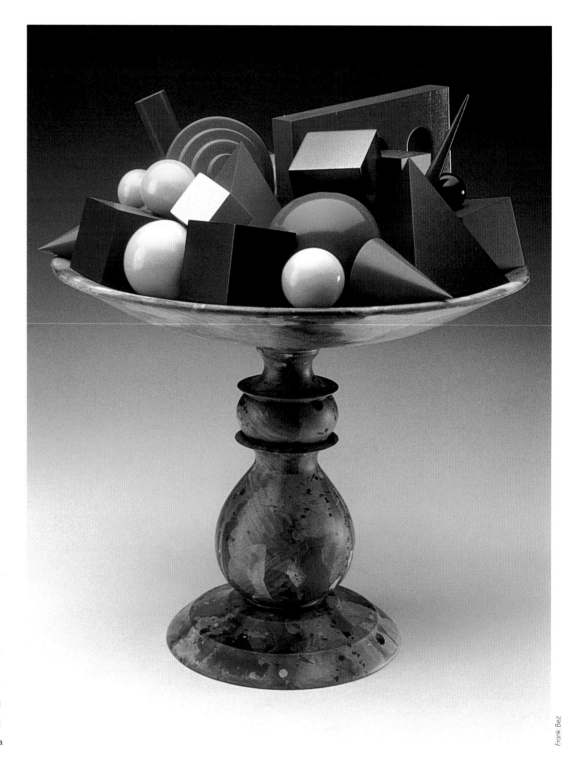

TITLE: De Chirico Salad, 1988
DESCRIPTION: Painted wood
DIMENSIONS: 14" x 12"Dia.

"I can tell you this: these objects
were my participation in a ten-
thousand-year-old tradition of
describing culture with a visual
language. Tools, techniques and
materials were a means to an end,
but never the end. Art equals
imagination. In some small way, my
effort is part of the complex visual
language interpreting this time and
place on the planet." — Hap Sakwa

Frank Bez

Mark Sfirri

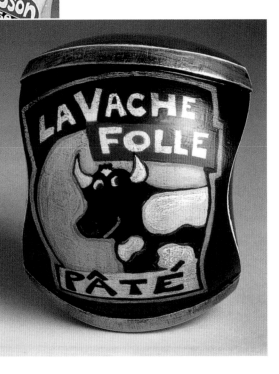

TITLE: Painted French Vessels, 2000

DESCRIPTION: Poplar and paint

DIMENSIONS: 3" to 13"H

"I paint representational imagery on my work. I show everyday objects in a context that allows the viewer to see them in a different light. I was fascinated by visits to the grocery store when I was in France, seeing products that were presented in a different way or that were completely foreign to me." — Mark Sfirri

TITLE: *La Vache Folle*, 2000

DESCRIPTION: Poplar and paint

DIMENSIONS: 6" x 4" x 3"

Photos: Mark Sfirri

Kim Kelzer

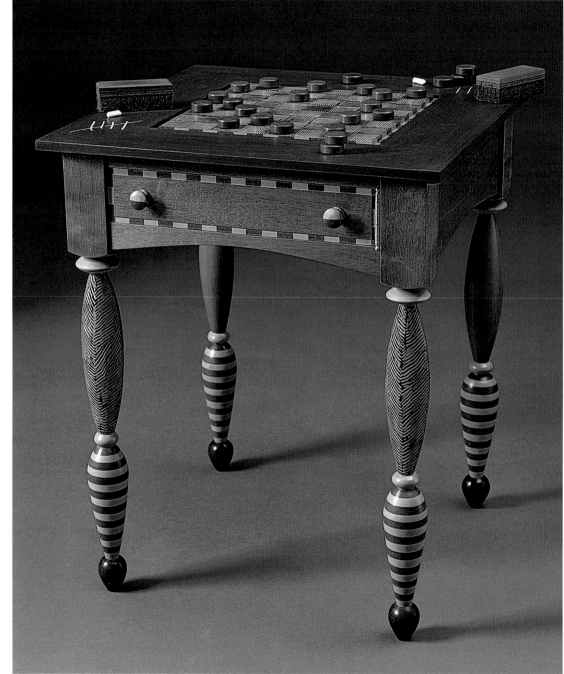

TITLE: Checkers II , 2001
DESCRIPTION: Mahogany,
milk paint and chalk-
board paint
DIMENSIONS: 30" x 26"
x 26"

Rachel Olson

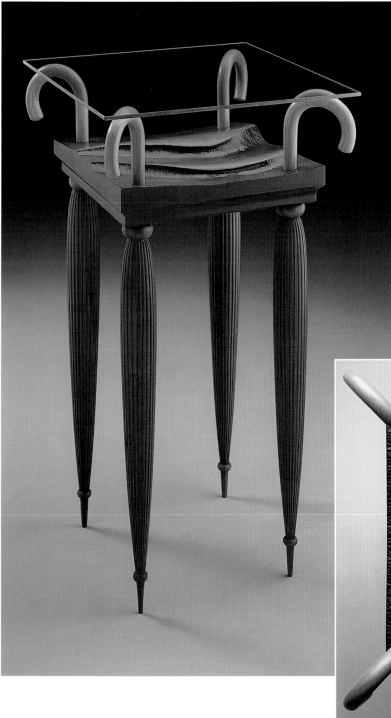

Photos: Dean Powell

Mitch Ryerson

TITLE: Water Table, 1998
DESCRIPTION: Swiss pear wood, walnut,
umbrella handles, glass and paint
DIMENSIONS: 32" x 17" x 17"

"The pieces I make surprise you with the commonplace.
Umbrellas, clothes, caulking guns — these are a few of the
everyday objects that find themselves in my work, not as
curious bric-a-brac, but as wise friends that have something
important to reveal. I want people to come away with their
curiosity aroused. My work is literal but it is also about form.
I use strong shapes and lines to convey, in the clearest way, a
sense of wonder at the world around me." — Mitch Ryerson

Alphonse Mattia

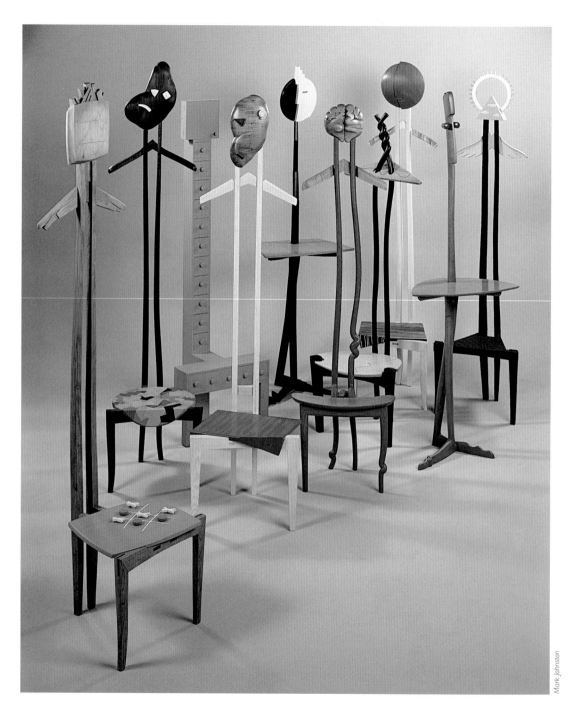

TITLE: Valets: Brains, Knot Head, Mr. Potato Head, 1984–85

DESCRIPTION: Assorted hardwoods, bleached, ebonized, painted and dyed

DIMENSIONS: 70" x 20" x 18"

"When I first started using paints it was a mild sort of rebellion from what I saw as the tyranny of the woodiness of wood. I'd had enough of it. But being still bound by reverence and respect, I found it difficult to completely obscure the rich textural quality of the woods I was working with."
— Alphonse Mattia

Mark Johnston

Andy Buck

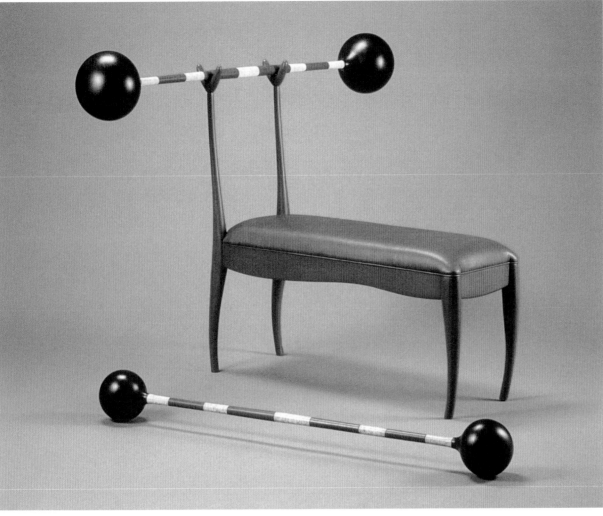

Bill Bachhuber

TITLE: Bench Press, 1999

DESCRIPTION: Wood, leather and paint

DIMENSIONS: 36" x 38" x 34"

"For me, it's really about trying to reach an elevated place, where feeling and doing become the same thing. I call it thinking with my hands." — Andy Buck

BALANCE

Jack R. Slentz, Room with a View, 2000,
madrone, 17" x 16" x 3".

We walk a fine line when we create our art. Every detail, stroke, position of parts and application of color contributes to the success and balance of the work. What combination from our bag of tricks will best suit the idea at hand? Each artist has his own private ritual to determine this. For artists like Garry Bennett, the combinations become intuitive, like improv woodworking; an old coffee can or a bucket can be transformed into a lamp — instantly.

Balance in our life is reflected by the balance in our work. We can speak metaphorically of our lives or relate our stories literally, but we choose to let the work speak for itself. "I don't like to blab about my work," says Ed Zucca. "It's purely visual. I let others find their own interpretation. Mostly it's pretty obvious."

Balance can be chaotic. Imbalance can, in fact, be balanced. Elements that push and pull at each other can be in balance. We can skew the rules of perspective, misalign the vanishing points, create contrasting visual termination points or add color to create balance.

Balance can be subtle, reflecting a quiet euphoria. Like a waft of exotic essence, it can creep up and envelop you.

Tom Eckert, *Stratagem*, 2000, polychrome wood, 13.5" x 15.5" x 13". "I try to create imitative images that produce irrational (if not pretentious) illusions for the audience. During the act of viewing, the observer is visually tricked and a tension is created between the object of fantasy and its true reality."

Jamie Robertson

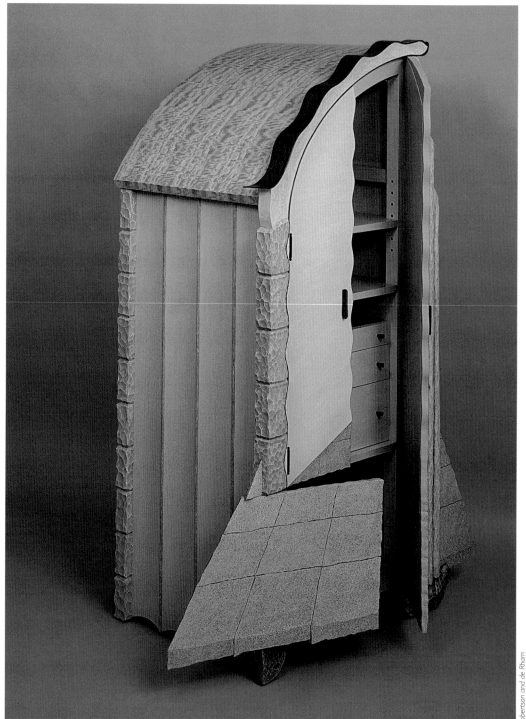

TITLE: Media Cabinet, 1994

DESCRIPTION: Lime wood, carved
and painted, mahogany, holly veneer
and faux granite

DIMENSIONS: 63" x 51" x 24"

"While I design work that is playful
and pleasing and engages the
imagination, it is also designed to be
perfectly useful. Each of my furniture
pieces is an art object. They each
redefine the distinction between
craft and art, between the exclusive
domains of function and aesthetics."
— Jamie Robertson

Robertson and de Rham

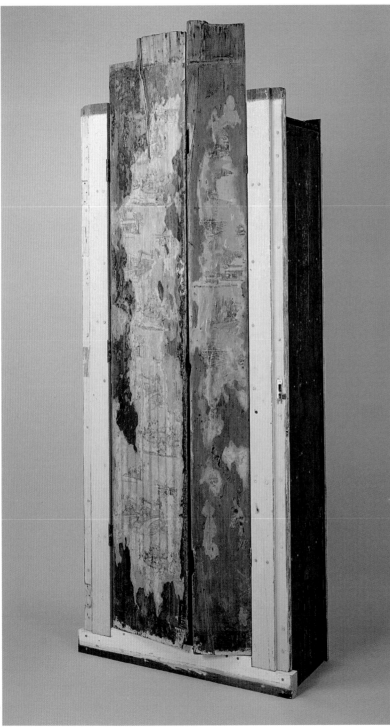

Mark Johnston

TITLE: Coverings, 1993
DESCRIPTION: Old wood, paint, and
cabinet with layers of old wallpaper
DIMENSIONS: 93" x 38" x 17"

"My creations in salvaged wood have grown out of that
'making do with what you have' kind of living. There is both
humor and hardship in that kind of life, as well as an ongoing
need to solve little and big problems, indoors and out, without
making a big deal of it all or missing too many beats. I hope to
express some of that sensibility and process in my work. I feel
like I am partly an archaeologist searching through the ruins of
New England, and partly an artist trying to make sense of the
disappearance of rural life." — Stephen Whittlesey

Fabiane Garcia

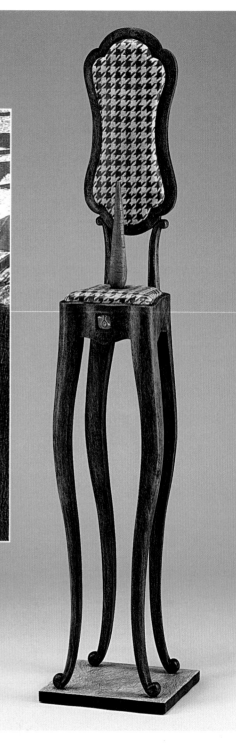

TITLE: Still Life, 1996

DESCRIPTION: Oil paint on wood

DIMENSIONS: 62" x 13" x 12"

"Each of my pieces is quite biographical in telling where my mind is and what I find important at a particular point in time. The subjects for each consecutive piece change rapidly as time passes, depending on what I read, see or hear, and also on how I react."

— Fabiane Garcia

John Eric Byers

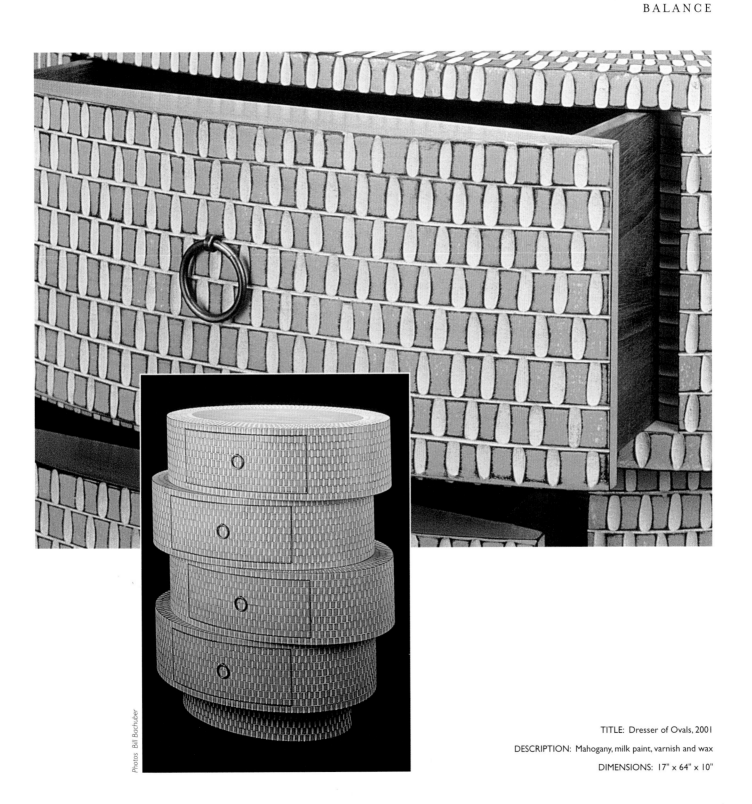

Photos: Bill Bachuber

TITLE: Dresser of Ovals, 2001

DESCRIPTION: Mahogany, milk paint, varnish and wax

DIMENSIONS: 17" x 64" x 10"

Brent Skidmore

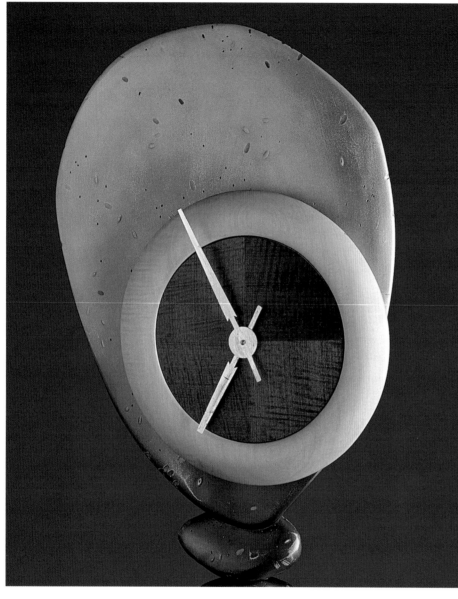

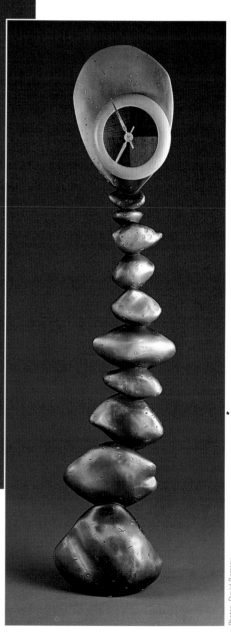

TITLE: Cairn Clock, 1999

DESCRIPTION: Basswood, pommele sapele, aluminum and acrylic paint

DIMENSIONS: 98" x 21" x 17"

"I was striving for a uniform and slightly monochromatic palette while creating a dynamic form
relationship. This grouping of colors was greatly influenced by an extended trip to the Utah deserts."
— Brent Skidmore

Photos David Ramsey

Susan Working

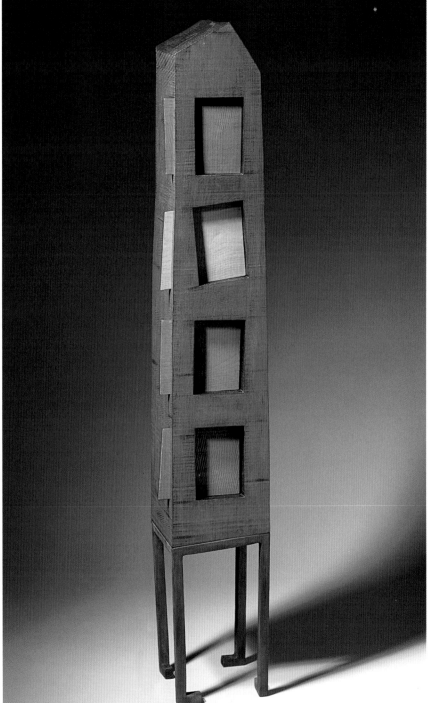

Kallen Nishimoto

TITLE: Bewitched, 2001

DESCRIPTION:

Polychrome ash

DIMENSIONS: 11" x

10" x 65.5"

Garry Knox Bennett

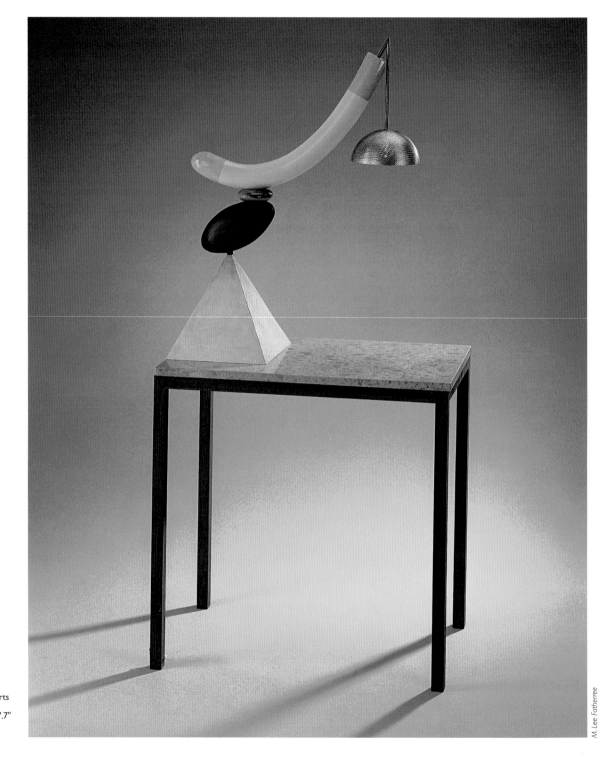

TITLE: Tablelamp #16, 2000
DESCRIPTION: Aluminum, wood, brass, ColorCore and lamp parts
DIMENSIONS: 62" x 17.7" x 29.7"

M. Lee Fatherree

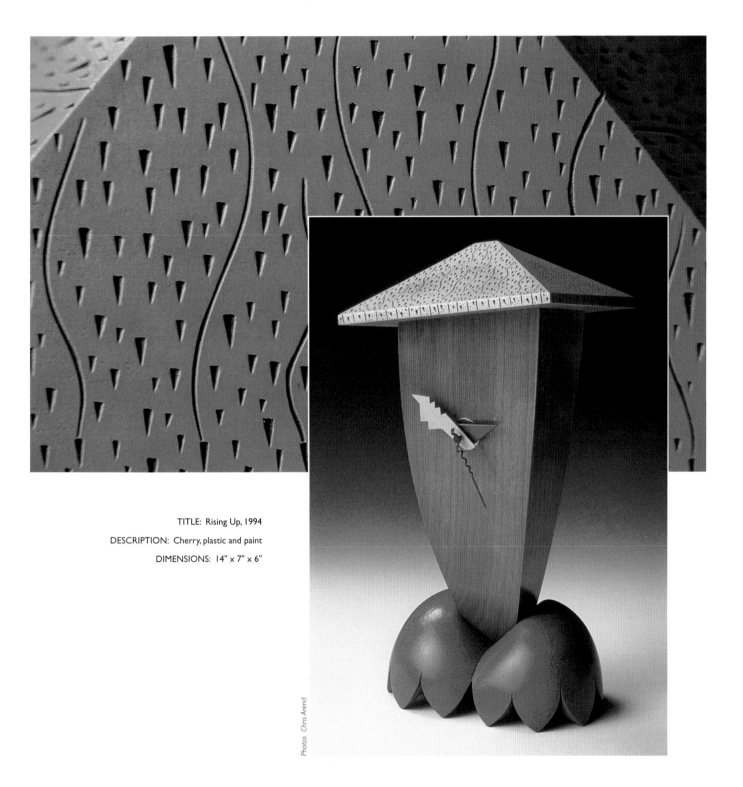

Lowell Zercher

TITLE: Rising Up, 1994

DESCRIPTION: Cherry, plastic and paint

DIMENSIONS: 14" x 7" x 6"

Photos Chris Arend

Ron Layport

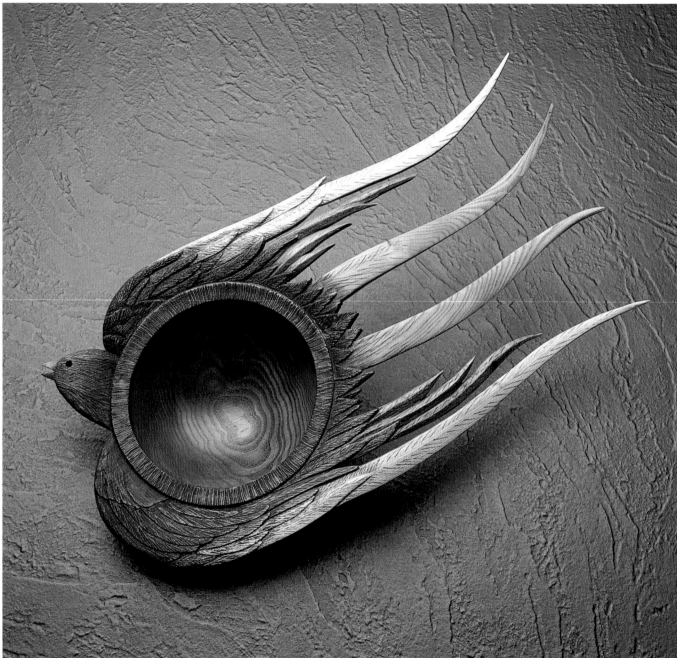

Chuck Fuhrer

TITLE: Swallow, 2001

DESCRIPTION: Dyed elm, turned, carved and textured

DIMENSIONS: 14.5" x 7" x 2.5"

Liz and Michael O'Donnell

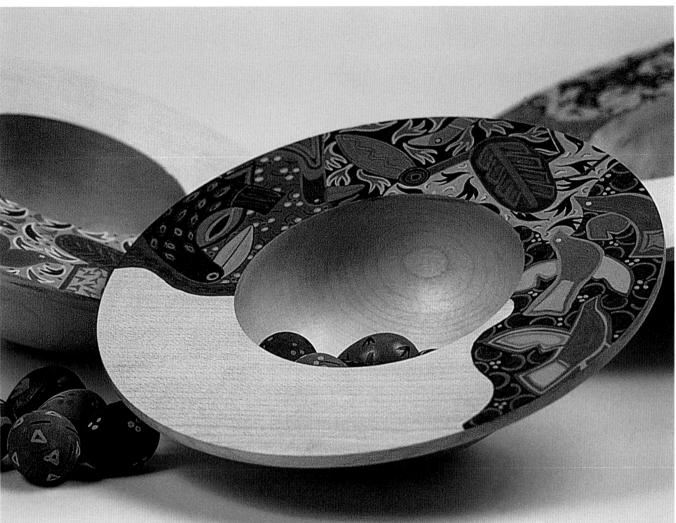

Joanne B. Kaar

TITLE: Nest Series, 1988

DESCRIPTION: Sycamore and paint

DIMENSIONS: 8.5"Dia. x 3.5"

"The movement of the *Nest* series of bowls also reflected the movement of a boat at sea. The Aboriginal culture had a great impact on us to the extent that we designed a bowl with a large flat surface that could be decorated with stylized bird shapes using earth colors." — Liz and Michael O'Donnell

Todd Hoyer

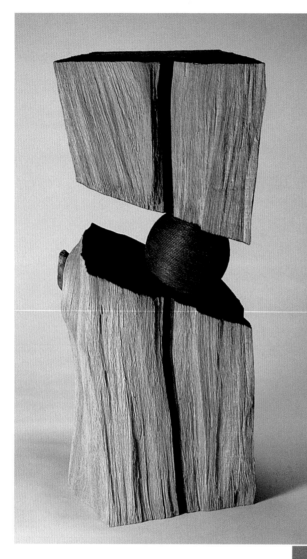

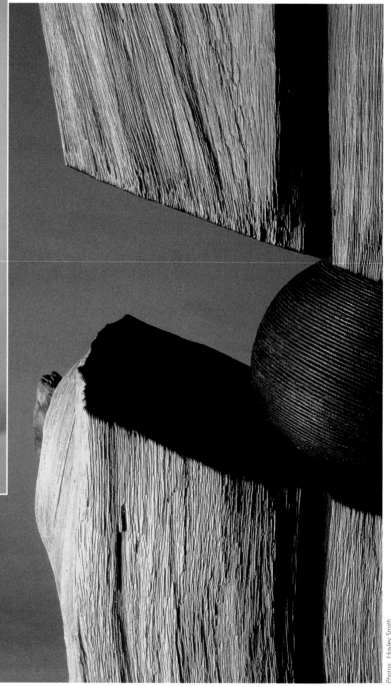

TITLE: Suspended Sphere Series, 2000

DESCRIPTION: Mesquite, split turned, carved and burned, and wire

DIMENSIONS: 20" x 9" x 9"

"I have developed a personal language through imagery. This surface reflects the struggles of the tree growing within its environment. The turned sphere represents purity and perfection within. It is surrounded by the dark void, created by the burned surfaces." — Todd Hoyer

86

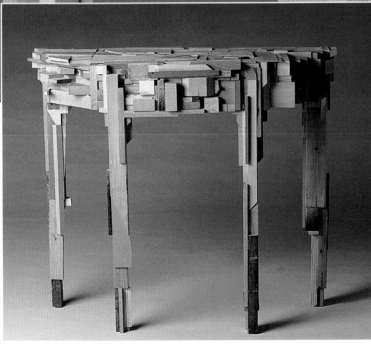

Photos: Elaine Brodie

TITLE: A Table Made of Wood, 2000

DESCRIPTION: Wood and glue

DIMENSIONS: 32" x 16" x 40"

"This piece was a desperate attempt to use up leftovers and at the same time cause furniture to happen quickly, as sketches or gesture drawings do." — Gordon Peteran

Michael Hosaluk

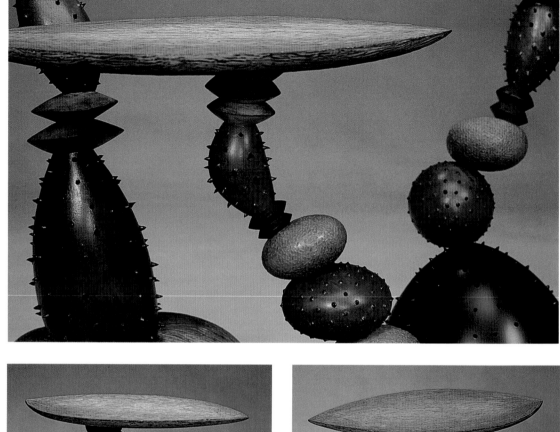

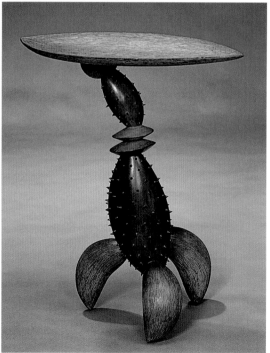

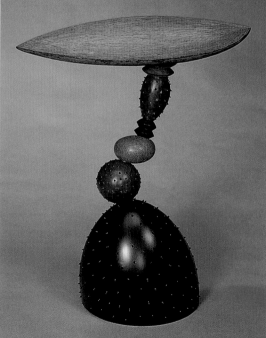

TITLE: Unusual Fruit Tables,
2000
DESCRIPTION:
Wood, acrylic paint,
gels and metal
DIMENSIONS: 26" x 21" x 14"

Photos: Grant Kernan

88

Richard Ford

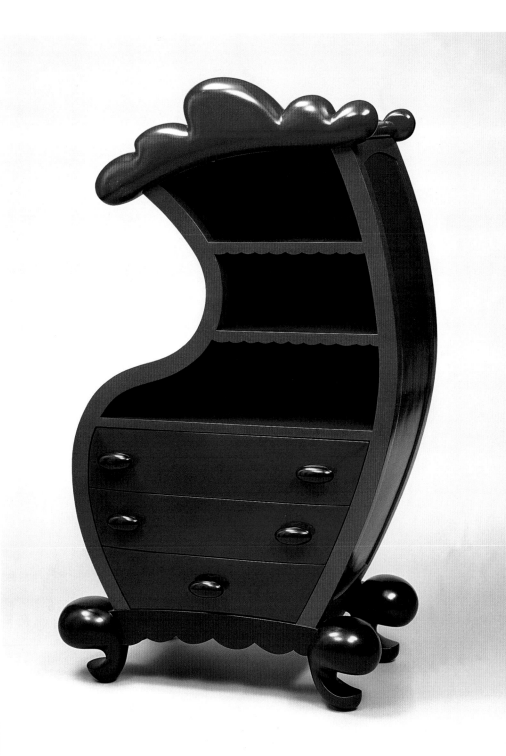

Bill Bachuber

TITLE: Hot as a Two-Dollar Pistol,
2000
DESCRIPTION: "Fordachromed"
poplar
DIMENSIONS: 65" x 18" x 48"

"I infuse my work with the
outlandishly colorful worlds that
animators create. Color and
surface design are the 'icing on the
cake' of my exaggerated forms. My
charge is to create a world of
furniture that is humorous, colorful
and functional." — Richard Ford

Joël Urruty

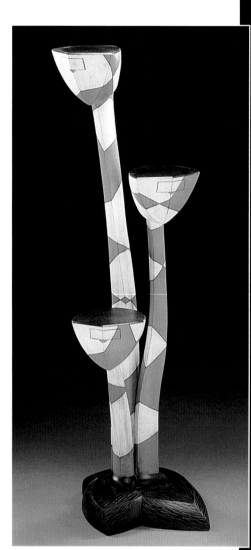

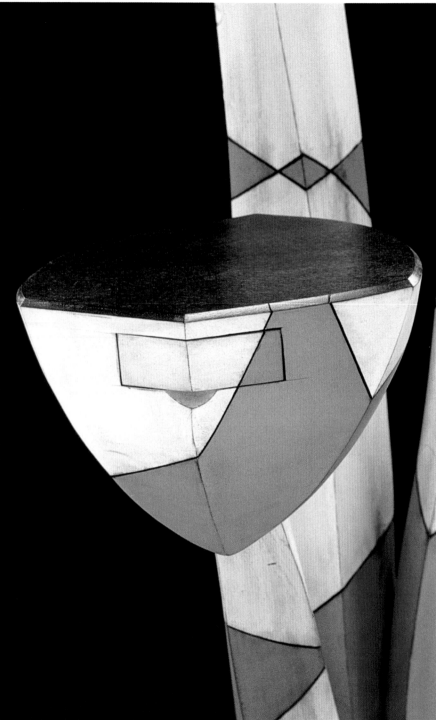

TITLE: Head of Drawers, 2000

DESCRIPTION: Mahogany and milk paint

DIMENSIONS: 7" x 20" x 16"

"I strive to create a contrast between the fluid curvilinear lines found in the forms of my pieces and the chaotic geometric lines of the surface treatment." — Joël Urruty

Dean Powell

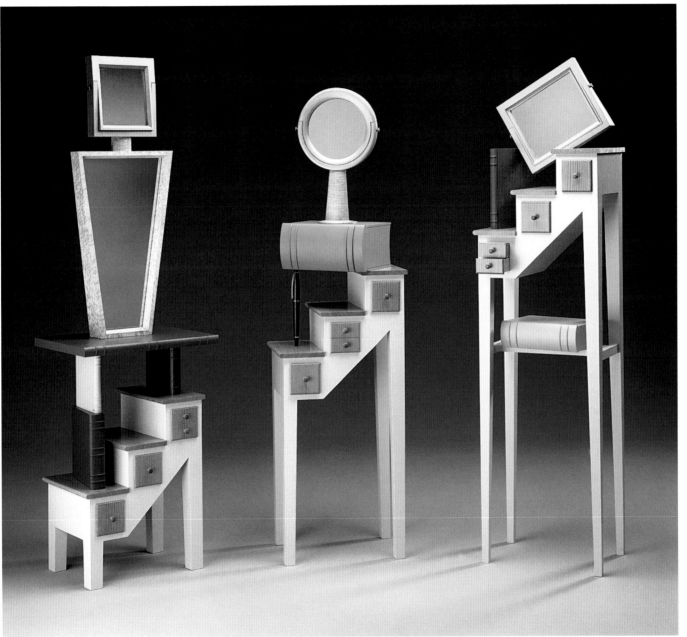

TITLE: Points of Reference: Atlas, Webster, Roget, 1995

DESCRIPTION: Fir, bird's-eye maple, gold leaf and painted wood

DIMENSIONS: 72" x 21.5" x 15.5"

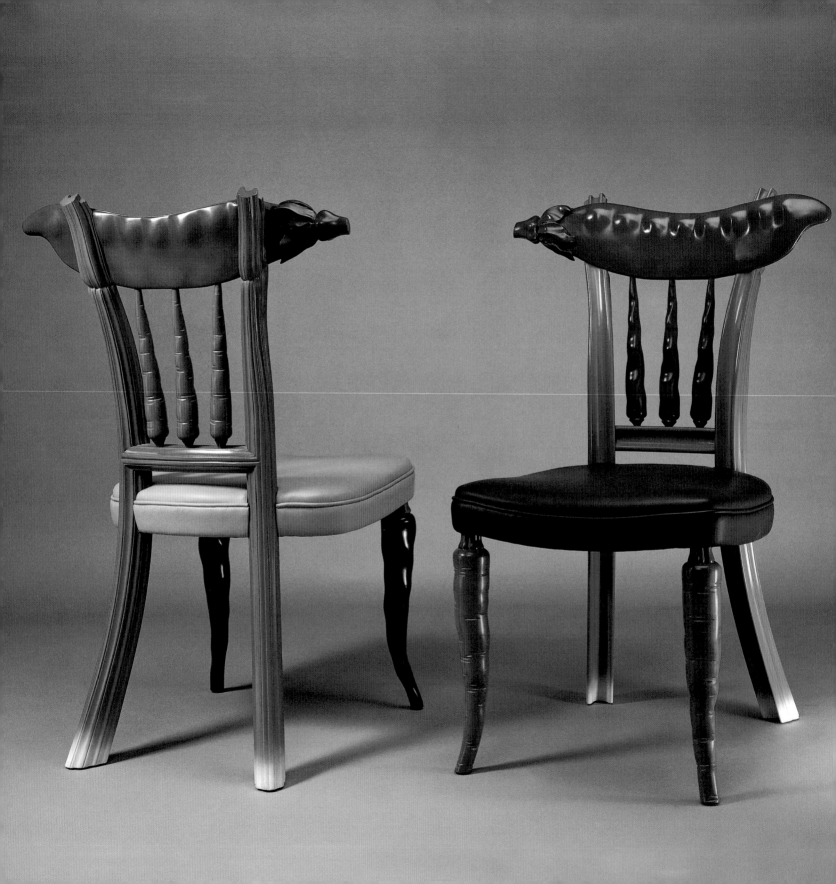

NATURE

Louise Hibbert, *Radiolarian Vessel III* (detail), 1999, 25"Dia.

Nature is a grand part of our daily lives. We cannot escape its influence. Its smell, sound, feel and the emotions it generates are with us on a personal level and are underlying influences on the art and craft of this world.

While some artists relate form and imagery directly to nature, others are influenced by the intangible, stimulated by their senses in their approach to their work. We are attracted to wood for its intrinsic beauty and for its potential for artistic expression. Artists may work with wood, but the material can be secondary if the ideas they are exploring require the introduction of other material to alter the surface.

The forces of nature can be used to sculpt surfaces that represent aging, for example. Todd Hoyer will leave his work exposed to the elements of the desert to develop a patina. Mark Orr uses salvaged, and sometimes weather-beaten, materials to portray an antique effect.

The rhythm and pattern created in the work are often subliminal. Many references are a reflection of natural instincts. "I've hung green over the side rail and felt the apprehension of an approaching fog," says Marilyn Campbell about her piece *Night Winds*. For others, it can be a bent tree that directs us to be creative. At our best, we don't copy nature; we are in tune with it.

Craig Nutt, *Celery Chairs with Carrots, Peppers and Snow Pea,* 1992, wood, leather and paint, 19" x 22" x 37".

Wendell Castle

TITLE: Four Seasons Clock,
1994
DESCRIPTION: Poplar,
jelutong and maple veneer
DIMENSIONS: 90" x 42" x 19"

"Anything I see, hear or read
may invade my work. I
probably misinterpret all this
information. What I saw was
not really what was there,
what I heard was not what was
really said, and what I read
really meant something else.
We comprehend and
understand only what we
already know, but we have no
idea what we know."
— Wendell Castle

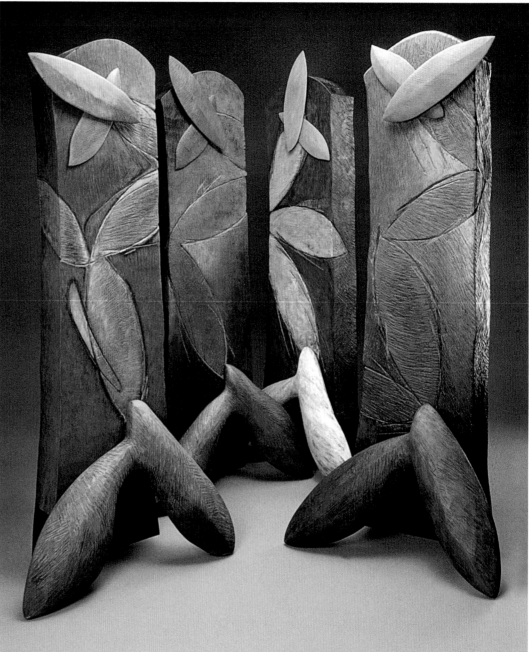

David Mohney

Michael Hosaluk

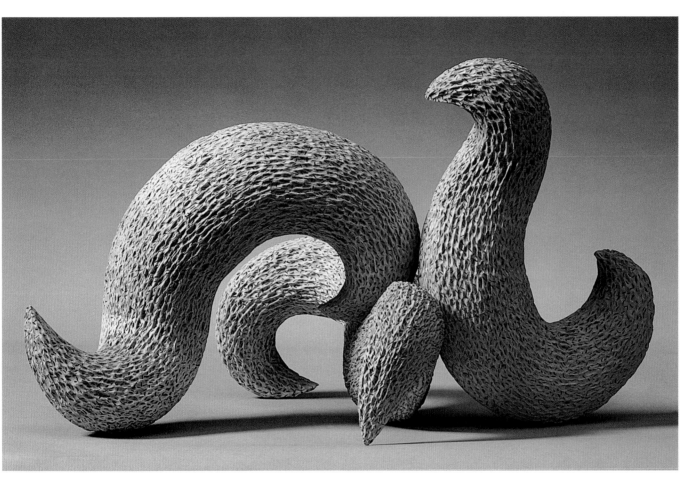

Grant Kernan

TITLE: From the Sea, 2000

DESCRIPTION: Maple, turned, cut,

carved, textured, burnt and bleached

DIMENSIONS: 18" x 12" x 10"

"In a walk along a beach, a found object can set you reeling in new

directions. This series of work is about the interaction of species."

— Michael Hosaluk

Judy Kensley McKie

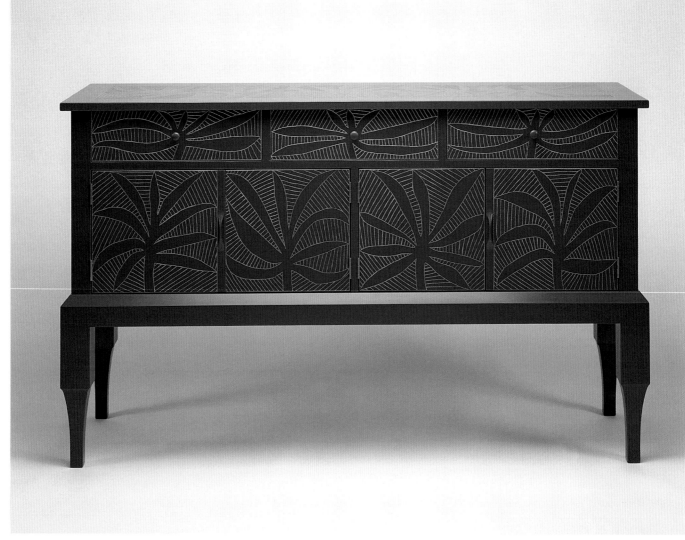

David Caras

TITLE: Chest, 1994

DESCRIPTION: Lime wood, carved and painted

DIMENSIONS: 36" x 60" x 18"

"I attempt to make objects that people will feel some joy in living with, and as a rule make only things that I would want in my own house. The design should be loose and the process should be as fun as possible." — Judy Kensley McKie

Jenna Goldberg

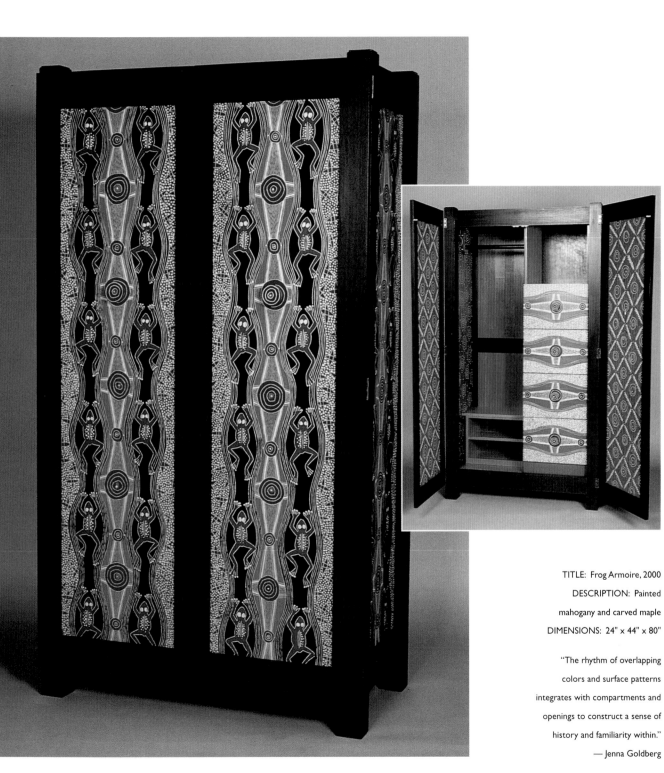

Photos: Tim Barnwell

TITLE: Frog Armoire, 2000

DESCRIPTION: Painted
mahogany and carved maple

DIMENSIONS: 24" x 44" x 80"

"The rhythm of overlapping
colors and surface patterns
integrates with compartments and
openings to construct a sense of
history and familiarity within."
— Jenna Goldberg

Jamie Russell and Reg Morrell

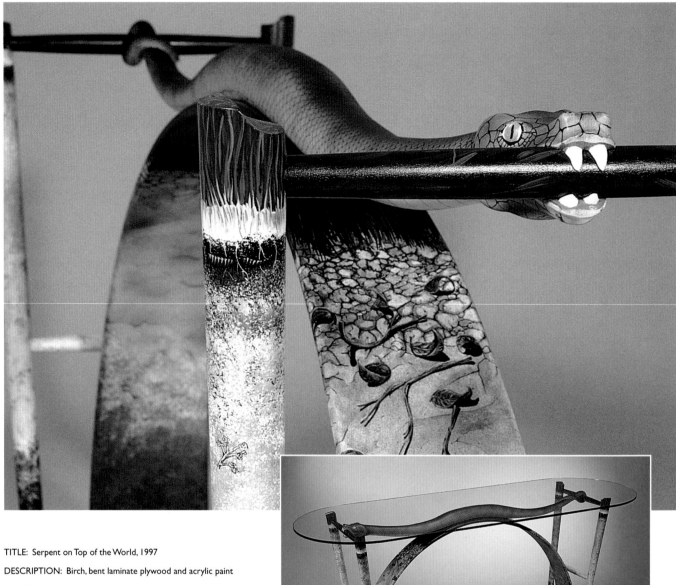

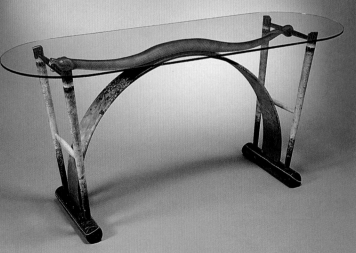

TITLE: Serpent on Top of the World, 1997

DESCRIPTION: Birch, bent laminate plywood and acrylic paint

DIMENSIONS: 50" x 30" x 22"

"For me the most important thing in making things is that I am driven by curiosity to see the finished piece." — Jamie Russell

Photos: Grant Kernan

Cathy Mix Robinson

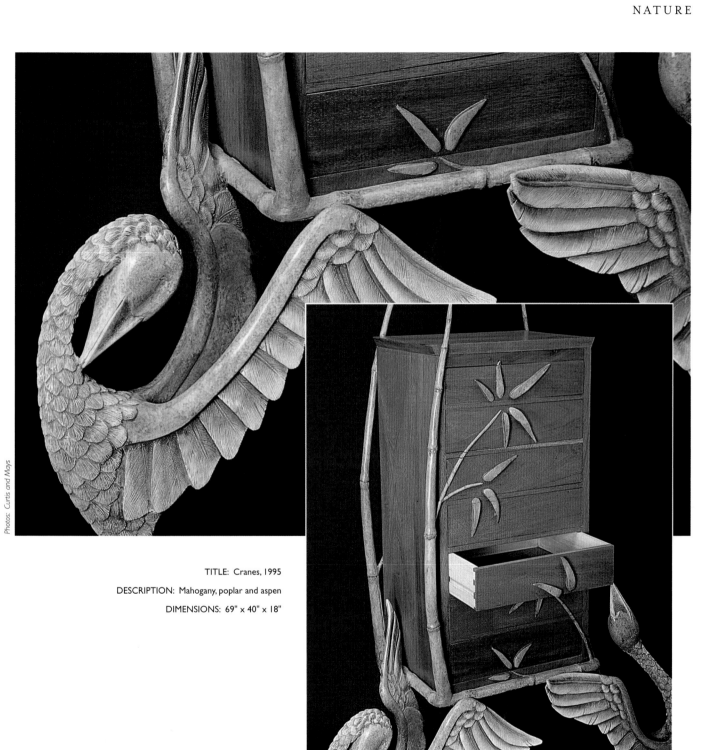

Photos: Curtis and Mays

TITLE: Cranes, 1995

DESCRIPTION: Mahogany, poplar and aspen

DIMENSIONS: 69" x 40" x 18"

99

Neil Scobie

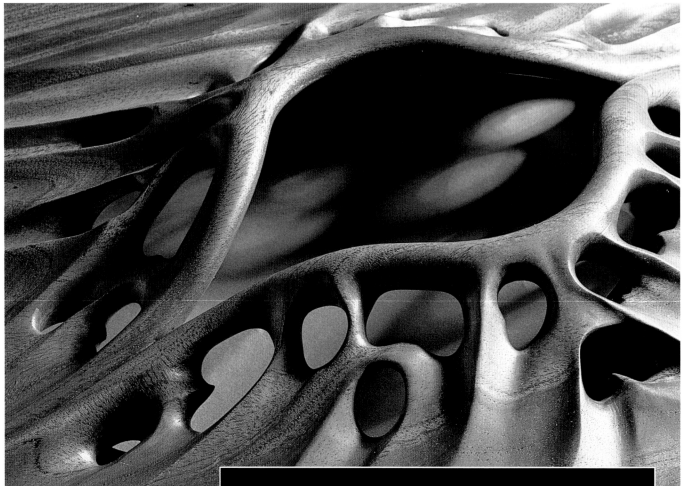

TITLE: Erosion, 2000

DESCRIPTION: Carved red cedar

DIMENSIONS: 13.8"Dia. x 3.5"

"The *Erosion* series has been inspired by the eroded gullies and hillsides that are so prevalent throughout our country. The effects of water running over rocks and tree roots in fast-flowing rapids have also inspired this series." — Neil Scobie

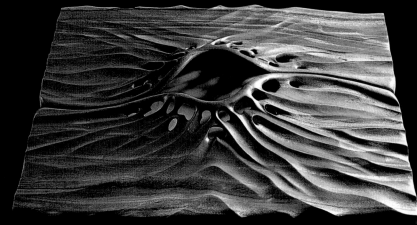

Photos: Neil Scobie

Binh Pho

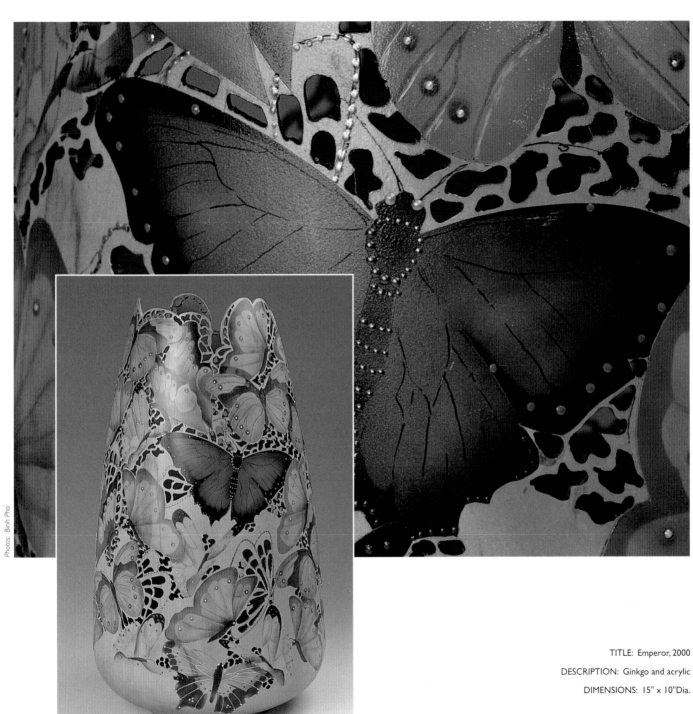

Photos: Binh Pho

TITLE: Emperor, 2000

DESCRIPTION: Ginkgo and acrylic

DIMENSIONS: 15" x 10"Dia.

"I put a soul into every piece I create. If the viewer picks up on the soul, then I've accomplished it." — Binh Pho

Marilyn Campbell

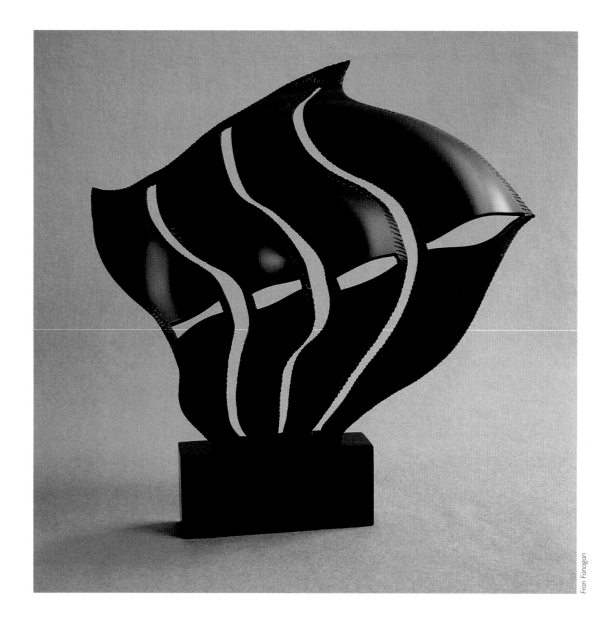

Fran Fanagan

TITLE: Night Winds, 2001

DESCRIPTION: Holly, epoxy, paint and ebony

DIMENSIONS: 12" x 12" x 3"

"Night Winds is a turning that took on a life of its own during its creation. What has
emerged is an object straight from my subconscious — an image of adventure and
anticipation, sails lifting high on a night wind." — Marilyn Campbell

David Sengel

Photos: Michael Siede

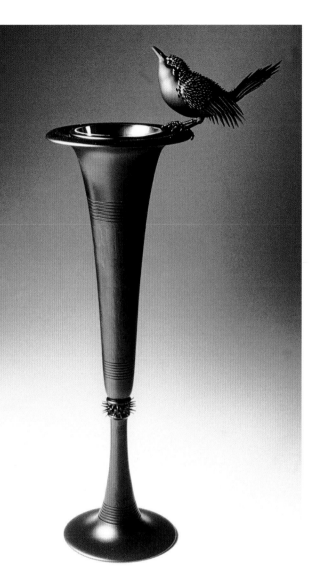

TITLE: Vase with Thorns, 1996

DESCRIPTION: Locust, rose thorns and crab claws

DIMENSIONS: 3" x 10"

"In my lengthy affair with thorns, one of the best uses has been the integration with a vessel form such that the thorns might seem a natural part of it. This piece in black suggests a mystery about what might be contained, with an appearance that is forbidding yet at the same time tempting." — David Sengel

TITLE: Corvus Ossifragus, 1996

DESCRIPTION: Ebonized cedar and box elder, rose and locust thorns

DIMENSIONS: 19" x 9"

Michael Hosaluk

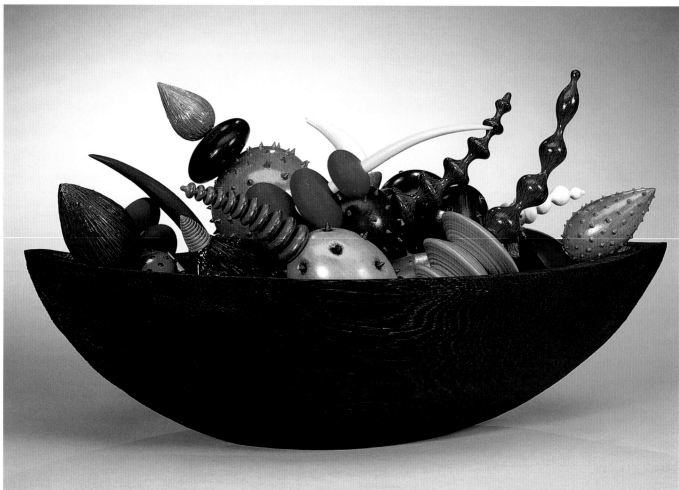

Grant Kernan

TITLE: Unusual Fruits, 2000

DESCRIPTION: Arbutus, ash, maple, paint, hair and copper

DIMENSIONS: 27" x 12" x 14"

Jon Brooks

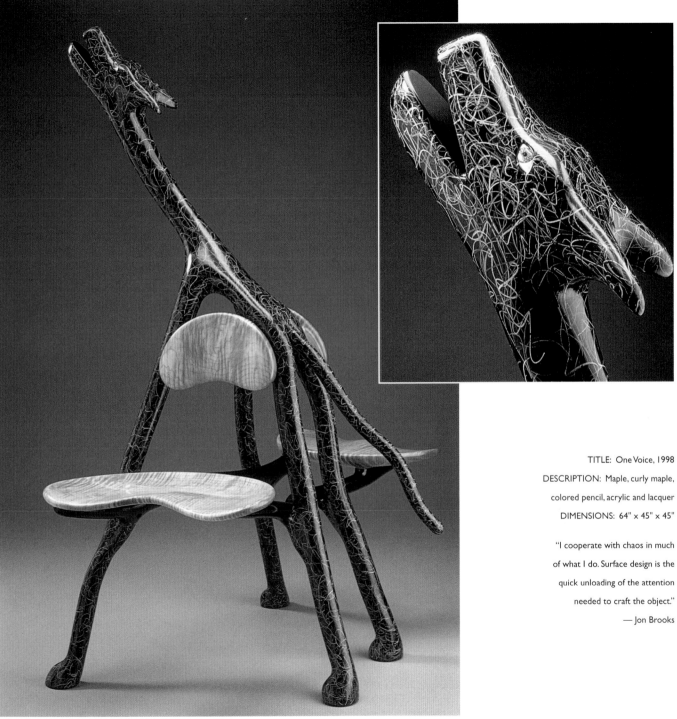

TITLE: One Voice, 1998
DESCRIPTION: Maple, curly maple,
colored pencil, acrylic and lacquer
DIMENSIONS: 64" x 45" x 45"

"I cooperate with chaos in much
of what I do. Surface design is the
quick unloading of the attention
needed to craft the object."
— Jon Brooks

Louise Hibbert

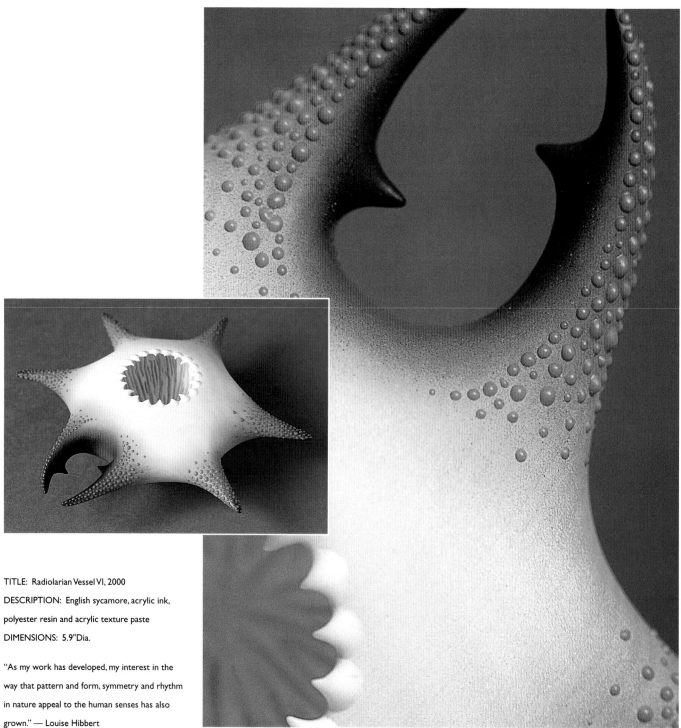

TITLE: Radiolarian Vessel VI, 2000

DESCRIPTION: English sycamore, acrylic ink, polyester resin and acrylic texture paste

DIMENSIONS: 5.9"Dia.

"As my work has developed, my interest in the way that pattern and form, symmetry and rhythm in nature appeal to the human senses has also grown." — Louise Hibbert

Photos: Frank Youngs

Todd Hoyer • Michael Peterson

Roger Schreiber

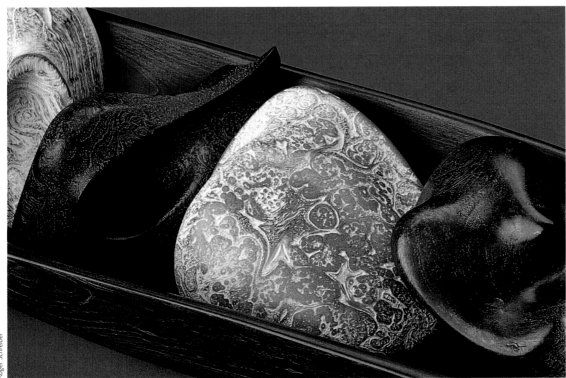

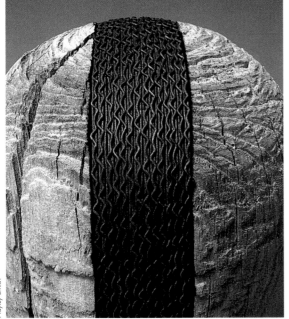

Hayley Smith

ARTIST: Michael Peterson

TITLE: Coastal Boat, 2000

DESCRIPTION: Pear wood, locust burl and carob

DIMENSIONS: 6" x 5" x 28"

"I wanted to further the visual and tactile connection of a landscape series in wood,
with the source of inspiration being stone outcroppings and land formations. I liked
the way the treatment paralleled the earth's own sculpting: forces of wind, sand,
sun and water working away on an object's surface." — Michael Peterson

ARTIST: Todd Hoyer

TITLE: Ringed Series, 1999

DESCRIPTION: Cottonwood and wire

DIMENSIONS: 14"H

"The aging process we all experience is represented in this piece. The turned form was weathered
outdoors for more than two years to create the gray surface patina. The wrapping of rusted wire
binds and seals the vessel form while adding to the image of an ancient object." — Todd Hoyer

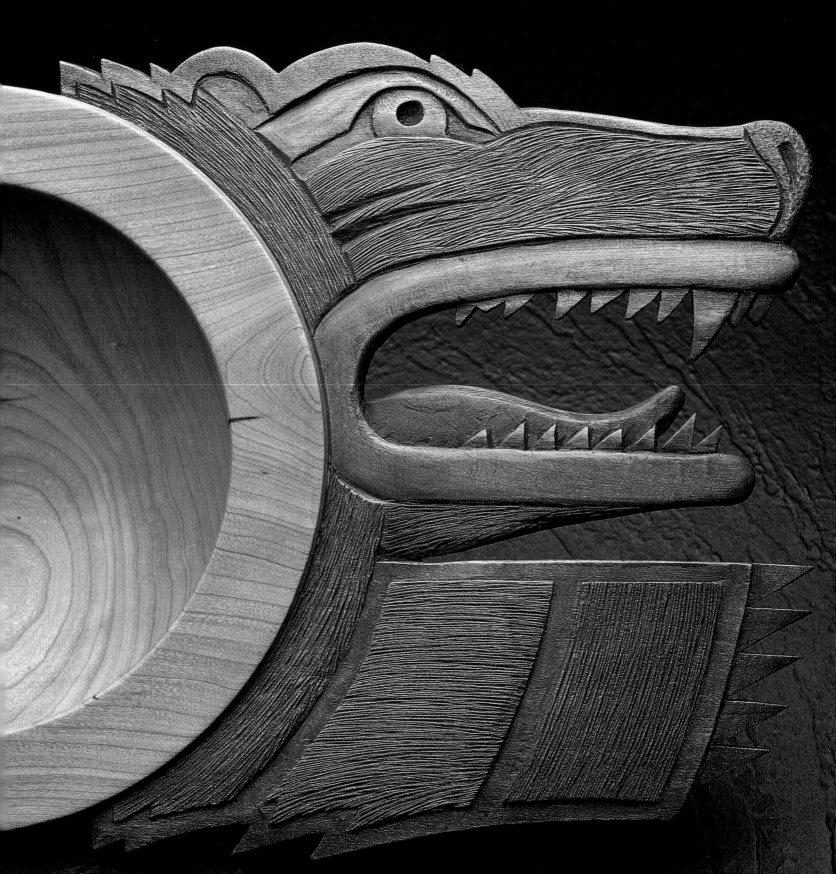

CULTURE

Rolly Munro, *Oceanic Angel*, 2001, walnut and pigments, 24" x 12"Dia.

Throughout history, men and women have created objects that express their cultures. These objects can be ceremonial, ritualistic or humorous. Objects, like experiences from our daily lives, are reflected in our art.

We breathe in our culture from the day we are born. Cultural experiences influence what we do in life; for artists, these experiences also influence what we create in our studios. We use cultural symbols, either existing or imagined. The marks and scribbles we make on the objects we create are part of an age-old tradition of describing culture using visual language. Color and surface connect us to one another and create a familiarity within the work that needs no explanation.

We immerse ourselves in the mystique of past cultures and find a sense of honor and appreciation within them, but we sometimes forget to see our own culture in the same respect. As we become history, our work will be looked upon with the same mystique.

For some, portraying culture in art is a spontaneous reaction to situations and material. For others, it is a deep-rooted, methodically processed source of expression. In both cases, it helps us understand, personally and culturally, who we are.

Ron Layport, *Bear*, 2000, turned, carved, textured and dyed, 19.5" x 8.5" x 2.75".

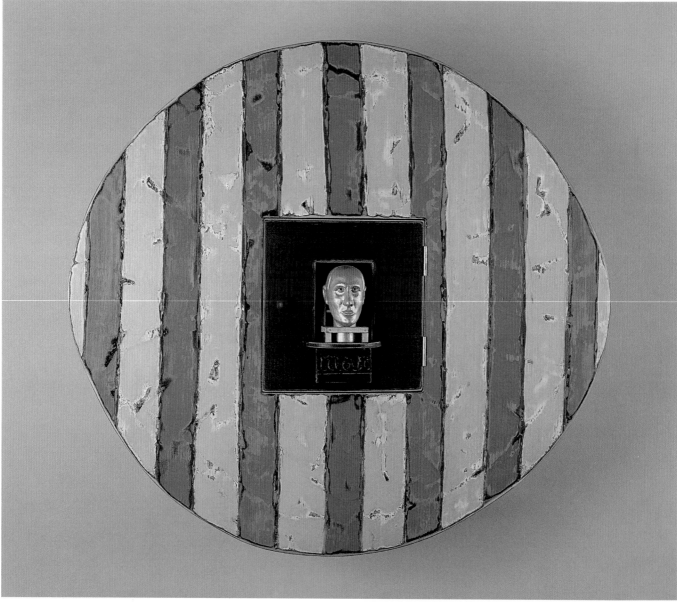

Martin Fox

TITLE: Man, 2000

DESCRIPTION: Painted and carved wood

DIMENSIONS: 30" x 42" x 8"

"The carved head was created by my father; I painted it gold. I loved the fluidity of the paint, holding the brush with a big glob of paint and sliding on the first coat, and how it transformed the piece from basic wooden structure to live focused object." — Randy Shull

Russell Baldon • Brian Gladwell

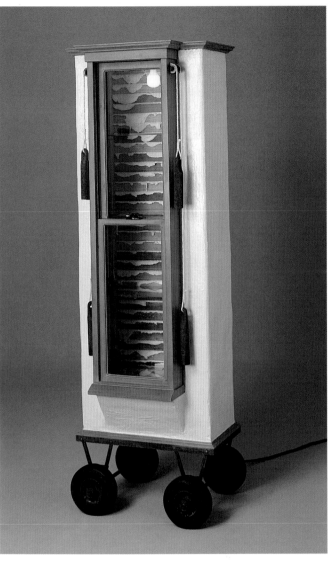

Ken Von Schlegel

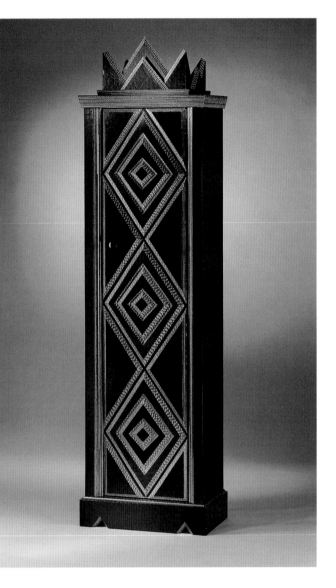

Grant Kernan

ARTIST: Russell Baldon

TITLE: Home Sweet Home, 1996

DESCRIPTION: Wood, plaster, steel, glass and rubber

DIMENSIONS: 74" x 30" x 27"

"Like a museum exhibit that seeks to expose something the public usually cannot see, this case shows the inside of a plaster-and-lathe wall. Voyeurism, public versus private space, and permanence versus transience are all important issues surrounding this work. The carcass as a whole serves as a metaphor for the individual who uses it." — Russell Baldon

ARTIST: Brian Gladwell

TITLE: Tall Cabinet, 1990

DESCRIPTION: Cardboard, lacquer and fiberboard

DIMENSIONS: 79.9" x 22.4" x 13.9"

"*Tall Cabinet* is part of a series in lacquered cardboard which at first appear to be solid and permanent, but become destabilized on closer inspection. The use of cardboard in this particular piece also allows it to participate in the sense of theatricality characteristic of the furniture of the Prairie folk artists." — Brian Gladwell

Michael H. de Forest

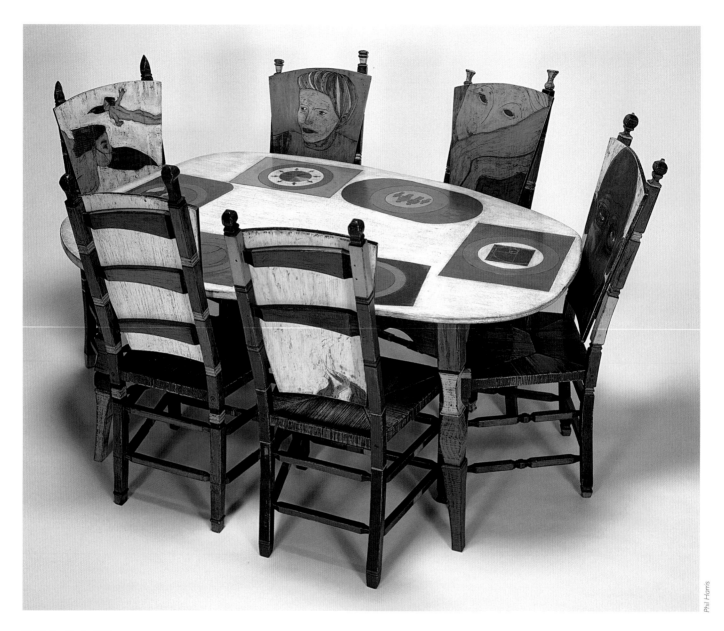

Phil Harris

TITLE: The Family, 1998

DESCRIPTION: Various woods, incised line carving and milk paint

DIMENSIONS: 29" x 63" x 45.5"

"Each chair is a portrait of a person. In front of each chair is a place mat and a plate with a symbol that refers to the personality. Societies have used the surfaces of belongings and surroundings to express cultural symbols for millennia. I wish to continue this tradition by using contemporary iconic imagery to imply myth and stories about my time and culture." — Michael H. de Forest

Andy Buck

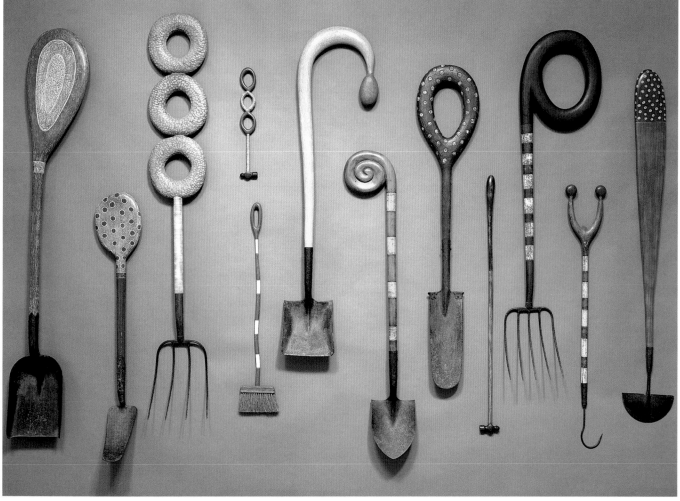

Phil Harris

TITLE: Rehandled Tools, 1999

DESCRIPTION: Painted wood and found implements

DIMENSIONS: Up to 72"H

David Fobes

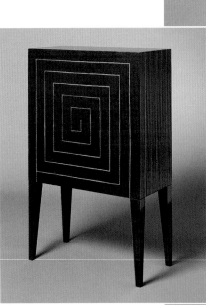

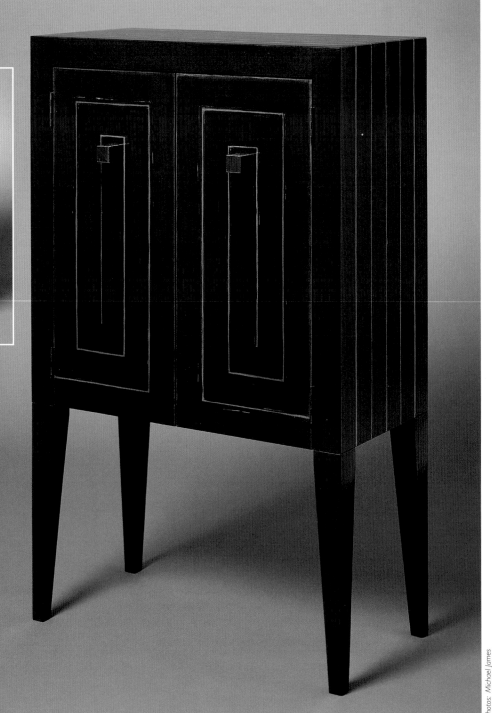

TITLE: Charm (front and
back views), 1998
DESCRIPTION: Baltic birch plywood,
birch, brass and acrylics
DIMENSIONS: 45" x 28" x 14"

"Charm, charmed, charming. An
object, a state of being and a personal
quality. Crimson is the color of lust,
desire and physical love, which can
become a maze of tangled emotion.
The cabinet dimensions are based on
the 'charmed' dimensions of the
golden triangle." — David Fobes

Photos: Michael James

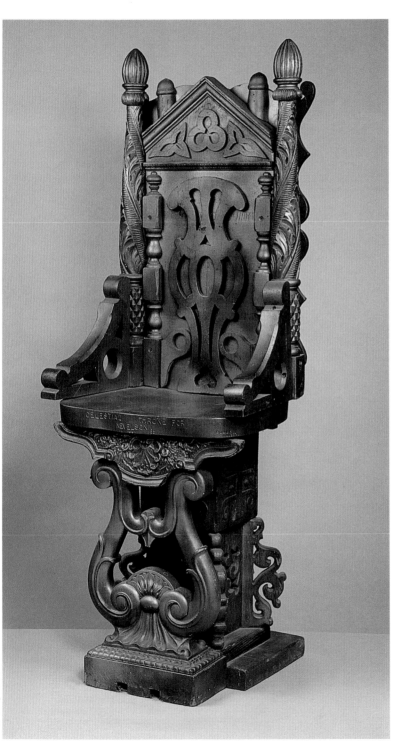

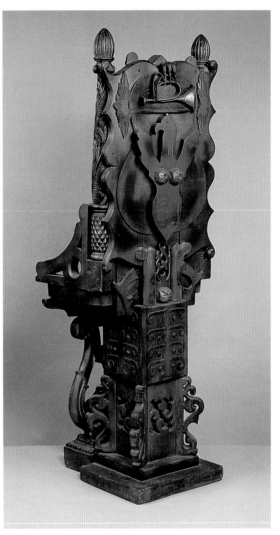

Photos: Bobby Hansson

TITLE: Celestial Throne for Nevelson, 1988

DESCRIPTION: Found wood, painted

DIMENSIONS: 54" x 27" x 25"

"I had a spray can of black in one hand and gold in the other and suddenly I was a New York City graffiti guy! I think I may have gotten a little woozy from the fumes, because it was so tremendously exciting to see the throne come to life with each squirt of color."

— Bobby Hansson

Michael Hurwitz

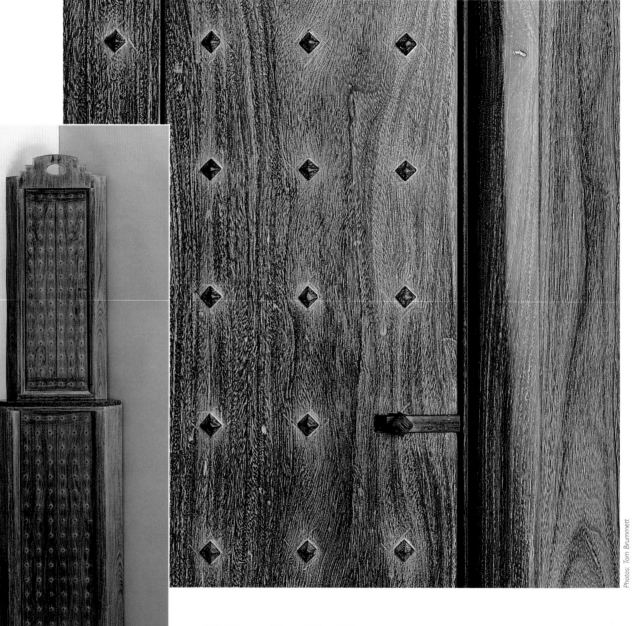

Photos: Tom Brummett

TITLE: Rosewood Corner Cabinet, 1989

DESCRIPTION: Mexican rosewood, sandblasted and painted

DIMENSIONS: 74" x 22" x 18"

"I was always interested in making furniture that alluded to architectural elements. That always intrigued me." — Michael Hurwitz

Michael Bauermeister

Photos: Michael Bauermeister

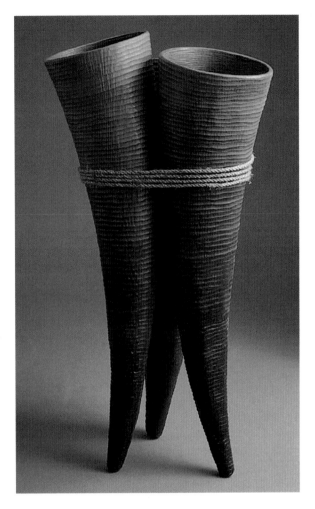

TITLE: Bundle, 2001

DESCRIPTION: White oak, rope and lacquer

DIMENSIONS: 40" x 20" x 20"

"The vessels can stand upright only when bound tenuously together with rope. This suggests and defies utility and mass production. The grooved texture over quartersawn grain also confounds understanding of technique." — Michael Bauermeister

Binh Pho

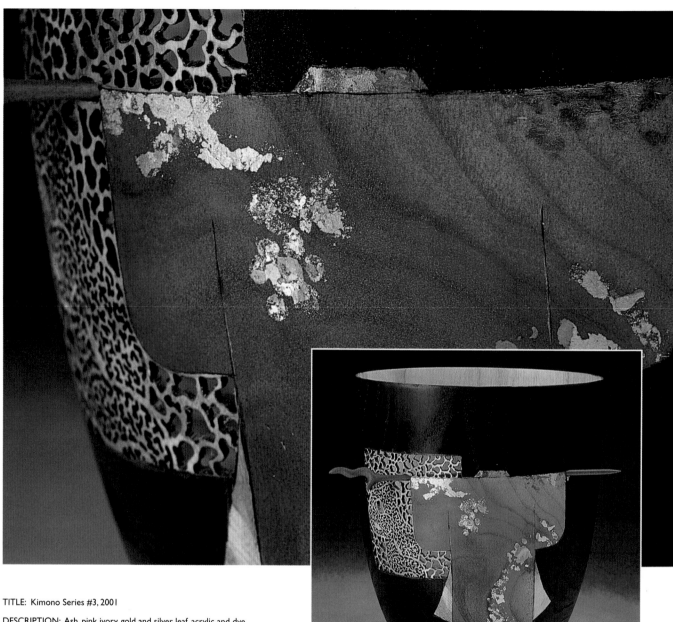

TITLE: Kimono Series #3, 2001

DESCRIPTION: Ash, pink ivory, gold and silver leaf, acrylic and dye

DIMENSIONS: 9" x 6"Dia.

"I laid out the kimono sketch with the grain orientation of the vessel to express the flow of water, airbrushed it with an acrylic blue to purple gradation, and then used a dusting technique to apply gold and silver leaf to give the kimono a flashy and rich look." — Binh Pho

Photos: Binh Pho

John Cederquist

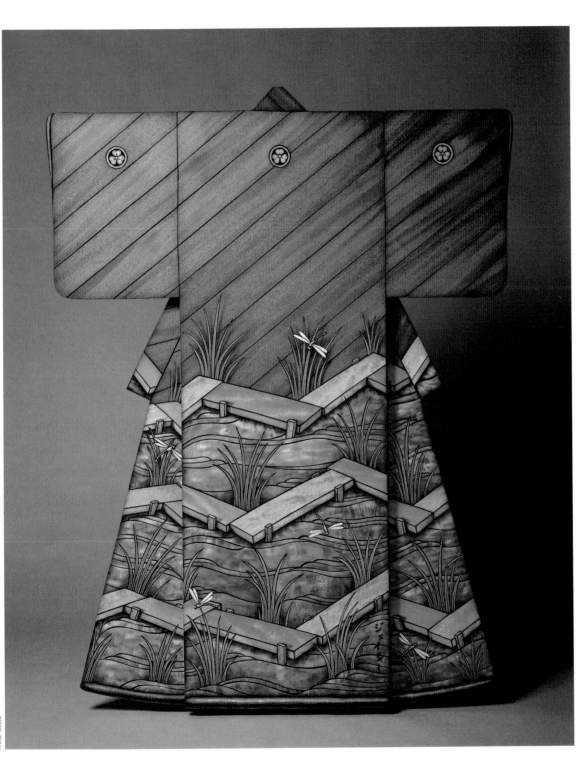

Mike Sasso

TITLE: Dragonfly,

2001

DESCRIPTION:

Various stained woods

DIMENSIONS:

70.5" x 54" x 19"

Steve Loar with Mark Sfirri

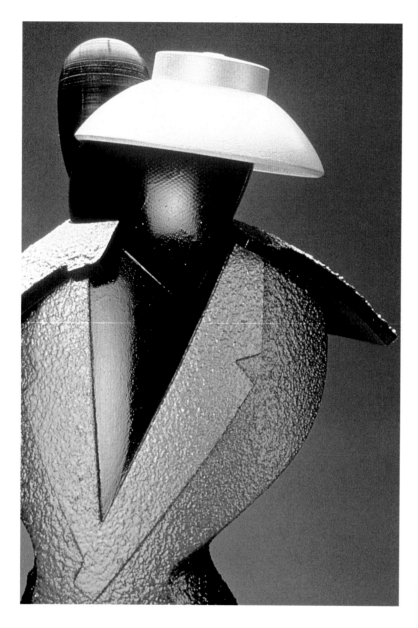

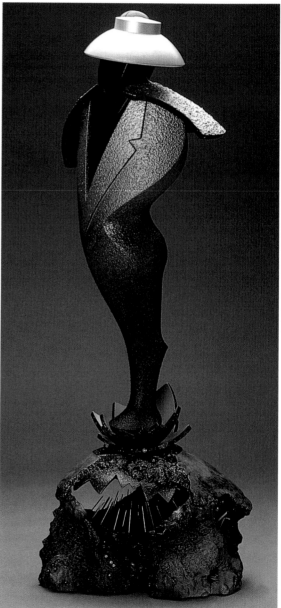

TITLE: Nikki's Lurid Past Comes Calling, 1997

DESCRIPTION: Poplar, cherry burl, ink, paint and mixed media

DIMENSIONS: 28" x 10" x 12"

"The utterly amoral protagonist of a book I was reading, *A Collector's Collector,* suggested a rich source of choreography for this composition. The base represents her sordid hidden self, which contrasts with her glamorous exterior figure." — Steve Loar

Lanie Gannon

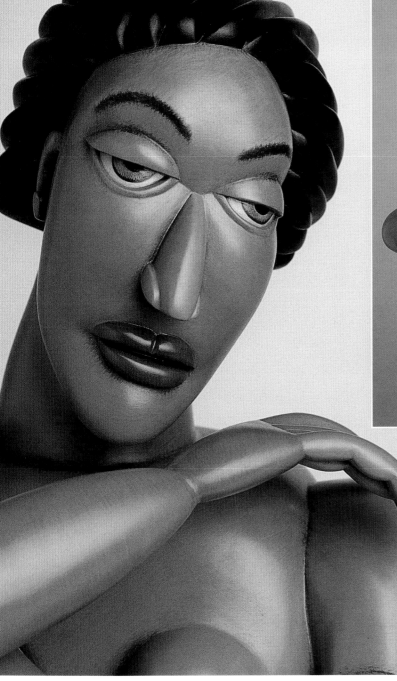

Photos: Greg Kinney

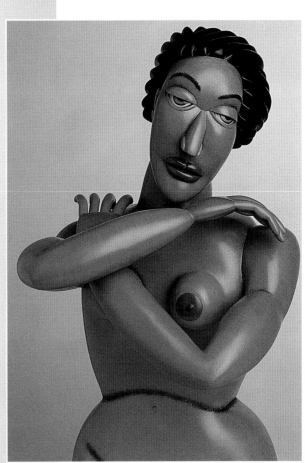

TITLE: Woman, 2000

DESCRIPTION: Wood and acrylic

DIMENSIONS: 29" x 18" x 12"

"I felt like this color choice would allude to the fact
that this piece was carved from wood, and also
enhance the highly stylized human form. Each layer
of paint becomes thinner (and there are many in
all), until the end when the paint is very thin and
watered down and acts very much like a glaze.
Some brush strokes are visible." — Lanie Gannon

Gael Montgomerie

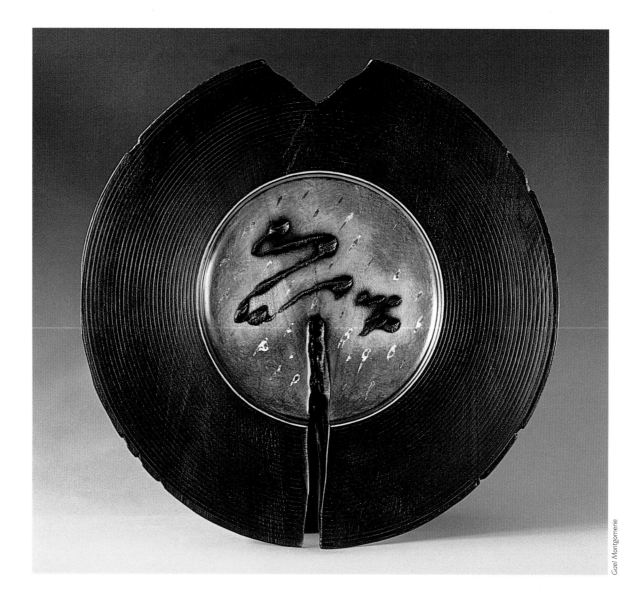

Gael Montgomerie

TITLE: Journey to New Mexico, 2001

DESCRIPTION: Maple, paint and silver leaf

DIMENSIONS: 15.4"Dia. x 1.8"

"My aesthetic exploration is concerned with finding a balance between the rigidity of wood, the formality of the turning process and the color and exuberance of the growing tree. This piece is about the New Mexico big skies, the stars and the bones of a very old civilization that lives on in spirit." — Gael Montgomerie

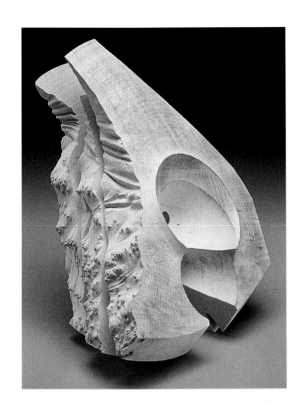

ARTIST: Stoney Lamar

TITLE: Passages: Landscape and Arch, 2001

DESCRIPTION: Bleached madrone

DIMENSIONS: 16" x 14" x 10"

ARTIST: George Peterson

TITLE: Doorway, Doorway, 2001

DESCRIPTION: Cherry, turned, carved and burned

DIMENSIONS: 22" x 26" x 6"

"I take an intuitive and spontaneous approach to my work. The action of shaping the wood with my handheld tools is gratifying in a basic way. As I work with the wood, I collaborate with it. The wood has a voice and I have a voice; we interact. The finished piece illustrates that interplay." — George Peterson

George Peterson · Stoney Lamar

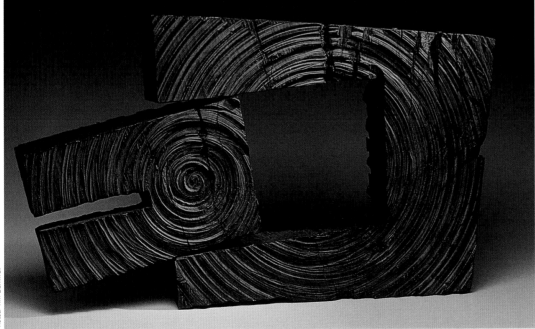

Photos: Tim Barnwell

123

Michael Scott

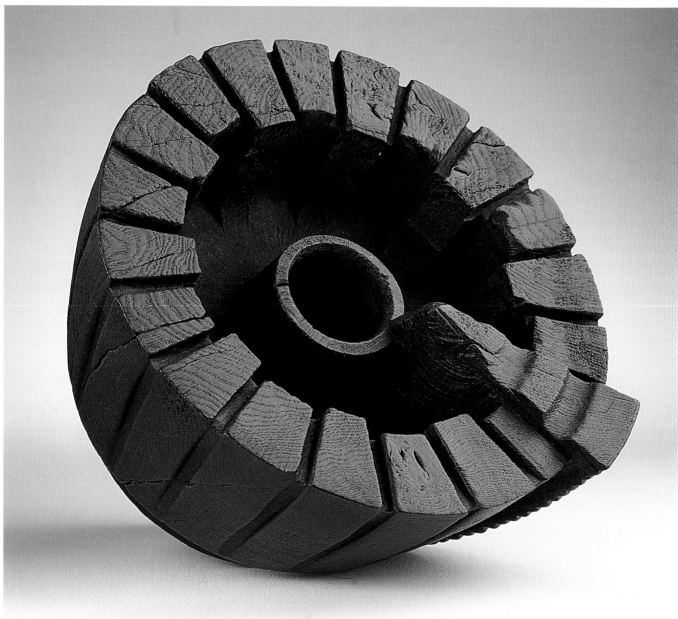

Tony Boase

TITLE: Castellated Form, 1996

DESCRIPTION: Elm, lathe turned, chain-saw carved and ebonized

DIMENSIONS: 12" x 8"

Terry Baker

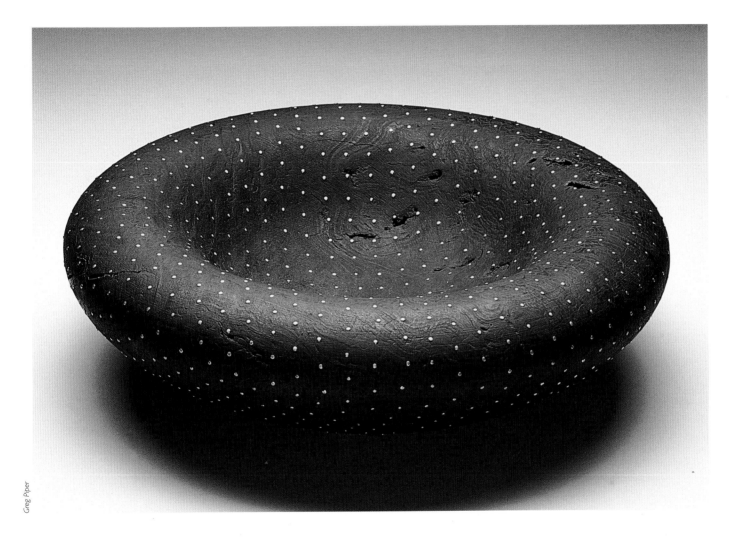

Greg Piper

TITLE: Ceremonial Series, 1999

DESCRIPTION: River red gum burl

DIMENSIONS: 18.9" x 5.5"

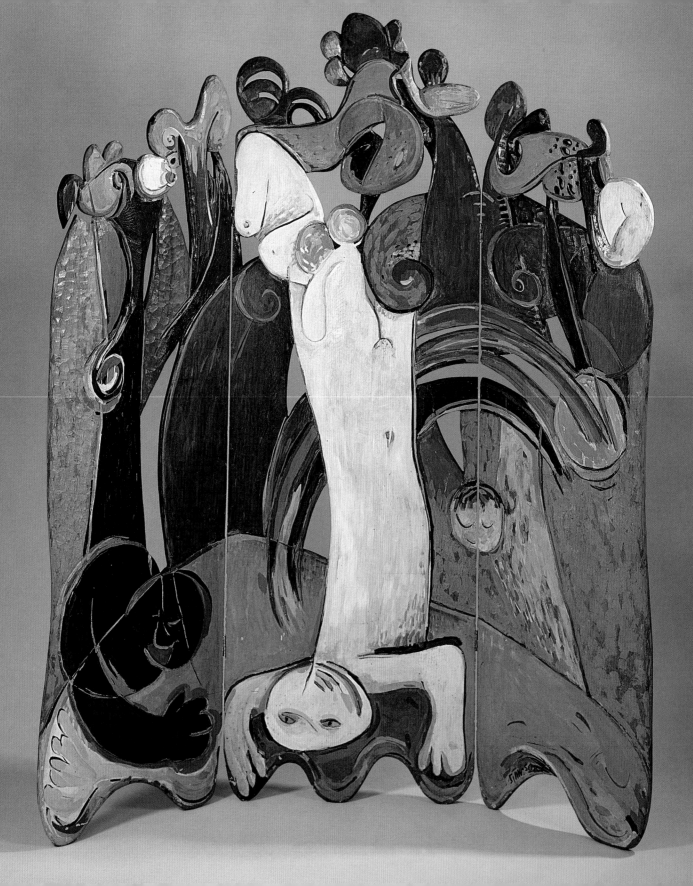

CONTRIBUTING ARTISTS

Terry Baker
Page 125

Russell Baldon
Page 111

Michael Bauermeister
Page 117

Garry Knox Bennett
Pages 15, 60, 82

Jon Brooks
Page 105

Christian Burchard
Page 32

Andy Buck
Pages 73, 113

John Eric Byers
Page 79

Graham Campbell
Page 47

Marilyn Campbell
Page 102

Wendell Castle
Pages 12, 19, 94

John Cederquist
Front cover
Pages 2-3, 36, 119

Michael Cullen
Pages 35, 46

Michael de Forest
Pages 37, 112

Robert Dodge
Page 4

David Ebner
Page 64

Tom Eckert
Page 74

David Ellsworth
Page 54

Emma Lake Group
Page 18

Douglas Finkel
Page 47

Patti and Ron Fleming
Page 9

Ron Fleming
Page 51

David Fobes
Page 114

Richard Ford
Pages 20, 89

Clay Foster
Page 52

Lanie Gannon
Page 121

Fabiane Garcia
Page 78

Mark Gardner
Page 50

Dewey Garrett
Page 30

Giles Gilson
Pages 8, 16

Brian Gladwell
Page 111

Jenna Goldberg
Page 97

Bobby Hansson
Page 115

Louise Hibbert
Pages 29, 93, 106

Stephen Hogbin
Pages 17, 25

Robyn Horn
Page 40

Michael Hosaluk
Pages 18, 88, 95, 104

Todd Hoyer
Pages 86, 107

Stephen Hughes
Page 43

Michael Hurwitz
Pages 62, 116

Kathie Johnson and Rob
 Gartzka
Page 56

John Jordan
Page 31

Kim Kelzer
Pages 15, 46, 70

Leon Lacoursiere
Page 24

Stoney Lamar
Page 123

Jack Larimore
Page 55

Ronald Layport
Pages 84, 108

Michael Lee
Page 41

Steve Loar
Page 120

Tom Loeser
Pages 6, 23, 34

Kristina Madsen
Page 38

Wendy Maruyama
Pages 14, 65

Alphonse Mattia
Pages 72, 91

Judy Kensley McKie
Pages 16, 96

John McNaughton
Page 66

Gael Montgomerie
Page 122

Rolly Munro
Page 109

Brad Reed Nelson
Page 61

Craig Nutt
Pages 59, 92

Liz and Michael O'Donnell
Pages 19, 85

Gavin O'Grady
Page 22

Mark Orr
Page 128

Gordon Peteran
Pages 16, 87

George Peterson
Page 123

Michael Peterson
Page 107

Binh Pho
Pages 101, 118

Peter Pierobon
Pages 39, 49

Cathy Mix Robinson
Page 99

Cory Robinson
Page 28

Jamie Robertson
Page 76

Jamie Russell and Reg
 Morrell
Page 98

Mitch Ryerson
Pages 17, 71

Hap Sakwa
Page 68

Paul Sasso
Pages 11, 57

Merryll Saylan
Pages 17, 53

Betty Scarpino
Page 26

Neil Scobie
Page 100

Michael Scott
Page 124

David Sengel
Page 103

Mark Sfirri
Pages 1, 18, 69, 120

Joanne Shima
Page 19

Yuko Shimizu
Pages 21, 47

Randy Shull
Pages 44, 110

Tommy Simpson
Pages 14, 45, 126

Brent Skidmore
Page 80

Jack R. Slentz
Page 75

Hayley Smith
Page 27

Rosanne Somerson
Page 48

Alan Stirt
Page 52

Frank Sudol
Page 66

Lynn Sweet
Page 67

J.M. Syron and Bonnie
 Bishoff
Page 33

Joël Urruty
Page 90

Jacques Vesery
Pages 42, 53

Stephen Whittlesey
Page 77

Susan Working
Page 81

Lowell Zercher
Pages 58, 83

Ed Zucca
Pages 14, 63

Tommy Simpson, *Tilly-Vally*, 1965, carved and painted wooden screen, 72" x 60".

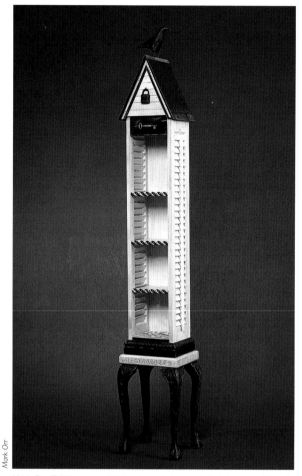

Mark Orr, *Tall Nevermore,* 2001, antique shutters and chair legs, metal, found objects and reclaimed wood, 73" x 12" x 12".